In the Mauritshuis Jan Steen

In the Mauritshuis

Jan Steen

Royal Picture Gallery Mauritshuis, The Hague
Waanders Publishers, Zwolle

This publication was produced
to accompany the exhibition
Spice of Life
Jan Steen in the Mauritshuis

Royal Picture Gallery
Mauritshuis, The Hague
3 March – 13 June 2011

The exhibition was made
possible by

SIEMENS

Introduction

The works of Jan Steen, one of the most popular painters of the Dutch Golden Age, are to be found in all the great museums of the world. His humorous scenes of everyday life, his depictions of dissolute households, of doctors, quacks and lovesick young women are known the world over, as are his portrayals of merrymakers at an inn, with rampaging children and undisciplined adults who invariably give a bad example. In fact, his boisterous scenes are so characteristic that 'a Jan Steen household' has become a common Dutch expression. Steen's work is recognisable, amusing and exceptionally versatile. He portrayed countless proverbs, but also produced a number of highly original portraits and many interesting history paintings, for which he drew upon his wide knowledge of the Bible, classical mythology, history, (comic) literature and drama. His work always focuses on human interaction, and he was unparalleled in his ability to illuminate its comic aspects. Jan Steen, a true storyteller and an outstanding painter with an extraordinary technique, left behind a large and varied oeuvre. The Mauritshuis owns a select ensemble of fourteen paintings by Steen — including such highlights as *'The Oyster Eater'*, *The Poultry Yard* and *'As the Old Sing, So Twitter the Young'* — which cover his entire artistic career and include almost every genre in which he worked. This book presents all the Jan Steens in the Mauritshuis, a choice group of works that offer a unique overview of his art.

Jan Steen his life

1626 Leiden
Born in Leiden in 1626, Jan Havicksz Steen was the eldest son of the beer brewer Havick Jansz Steen (1602–1670) and Elisabeth Capiteyn (†1669), who had married in November 1625. The Steens were a well-to-do Catholic family. As none of Leiden's Catholic baptismal registers from that time have survived, Jan Steen's exact date of birth is not known, but we can deduce the year from a document dated November 1646, in which he declares his age to be twenty.

1646
In November, twenty-year-old Jan Steen enrolled in the Department of Letters at Leiden University, presumably after receiving the necessary grounding at the Latin School.
It is unclear whether Steen actually studied at the university, because he never obtained a degree. His enrolment might have been a way of taking advantage of certain privileges enjoyed by university students, such as exemption from civic guard duty and from the municipal excise tax on beer and wine.

1648
18 March: Jan Steen registered as a master painter with the Leiden Guild of St Luke. The documents do not tell us with whom he trained. The artists' biographer Arnold Houbraken (1660–1719) gives Steen's teacher as Jan van Goyen, but according to Jacob Campo Weyerman (1677–1747), Steen was a pupil of the Utrecht painter Nicolaus Knüpfer before studying with Van Goyen and finally with the Haarlem painter Adriaen van Ostade.

1649–1654
The Hague 3 October: In The Hague, Jan Steen married Margriet (Grietje) van Goyen, daughter of the landscape painter. The couple continued to live in The Hague for a while, probably in one of the houses owned by Jan van Goyen. It is not known whether, after marrying, Steen set up as an independent master in The Hague or worked in his father-in-law's studio there. He remained, at any rate, a member of the Leiden Guild of St Luke.

1651
6 February: Steen's eldest son, Thaddeus, was baptised is the Catholic church in the Oude Molstraat in The Hague. His daughter Eva would be baptised in the same church two years later.

1651
July: At an auction in The Hague, the commercial agent Harald Appelboom bought four paintings by Jan Steen for the Swedish field marshal Karl Gustav Wrangel, who would later build Skokloster Castle in Sweden. One of these paintings still hangs in that famous castle. Apparently Steen's reputation as an outstanding painter crossed the Dutch border early on in his career.

1653
16 April: Steen paid another two-year contribution to the Leiden Guild of St Luke. The accounts contain the note: 'has lived outside this city in previous years'.

1654–1657 Delft
22 July: Jan Steen rented the brewery *De Slang* ('The Serpent'), also known as *De Roskam* ('The Curry Comb'), on the Oude Delft canal for 400 guilders a year. His father, Havick, acted as guarantor. The rental began on 1 November (All Saints' Day), after which Steen and his family moved into the house belonging to the brewery. It is possible that Steen's decision to become a brewer was prompted by the collapse of the art market caused by the First Anglo-Dutch War (1652–1654). Steen's brewing career was unsuccessful, however, and he left Delft before his three-year lease had expired.

1657/58–1660 Leiden and Warmond
At some point in 1657, Steen returned to Leiden, but soon afterwards moved to Warmond, a village north of Leiden. In April 1658 he paid his contribution to the Leiden Guild of St Luke. In Warmond, Steen painted in 1660 *The Poultry Yard*, which is, in fact, a portrait of the young daughter of Jan van Wassenaer, the Catholic lord of Warmond.

1660–1670 Haarlem
The Steen family moved to Haarlem, where their son Havick was baptised in the Catholic church on the Begijnhof on 4 August 1660. His birth was followed two years later by the birth of another daughter, Elisabeth, and even later by Johannes and Constantinus, but the years of these sons' birth are unknown. Nor do we know where in Haarlem the Steen family lived. Steen often found himself in financial difficulty.

1661
In this year Jan Steen became a member of the Haarlem Guild of St Luke.

1669
8 May: Margriet van Goyen was buried in Haarlem's Grote Kerk. Steen could not pay the bill presented by the apothecary who supplied his wife with medicine during her final illness.

1670–1679 Leiden
Jan Steen inherited from his parents a house on the Langebrug in Leiden. He and all his children went to live there, and he again registered with the Leiden Guild of St Luke. A prominent artist, he held several important posts in the guild: in 1671 and 1672 he served as senior officer, and in 1674 he was even appointed dean. According to Steen's biographers, he was still being pursued by creditors in Leiden, and also spent a lot of time smoking and drinking with his painter friends Jan Lievens, Arie de Vois and Frans van Mieris.

1672
In this 'Year of Disaster' Steen received permission from the city to open up an inn. His son Cornelis (Kees) acted as 'the maid', according to Campo Weyerman.

1673
22 April: Jan Steen married Maria Dircksdr van Egmond († 1687) in Leiderdorp. He already had six children, and she had two. Houbraken reports that Maria boiled sheeps' heads and trotters and sold them at the market. Their son Theodorus (Dirck) was baptised at the Catholic church in the Kuipersteeg in 1674.

1679
3 February: Jan Steen was buried in the family grave in the Pieterskerk in Leiden. His estate was heavily encumbered with debt. A year after his death, his widow was forced to sell the inn, and in 1686 even the family grave. After Maria's death in 1687, many of Steen's children and grandchildren found themselves in difficult circumstances; some of them died young, ended up in the orphanage, or left for the Dutch East Indies. Others were more fortunate: two sons, Thaddeus and Cornelis, followed in Steen's footsteps and became painters. Dirck, the youngest of the family, trained as a sculptor at the orphanage and, according to Houbraken, found work at a German court.

Jan Steen
Self-Portrait, c. 1670. Canvas, 73 × 62 cm
Rijksmuseum, Amsterdam

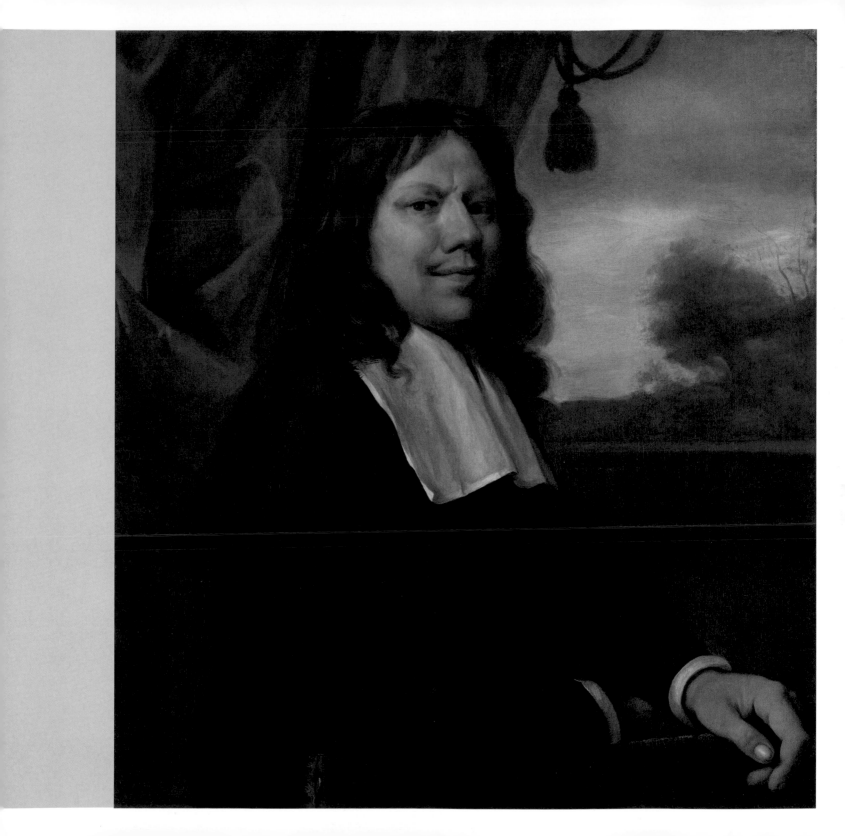

Storyteller

Jan Steen was a true teller of stories — stories that revolve around people, with all their emotions, weaknesses, bad habits and lack of manners. His stories — which often treat the joys and sorrows of courtship, marriage, housekeeping and child-raising — not only teach us a lesson, but also make us laugh. On rare occasions Steen painted a single figure, but even in such pictures, there is always something going on, such as in the *Woman Playing a Cittern* (p. 37), who smiles coyly at us. He usually painted a group of figures, however, sometimes even a multitude, arranged in many little scenes and engaged in a wide range of activities, as we see in *The Life of Man* (p. 59). Steen stage-managed his compositions carefully, as though they were scenes in a play. And he frequently introduced himself, or another narrator, to comment on the action — with a wink to the viewer, who often has a better idea of what is going on than the figures themselves. As on the stage, the characters' interaction was crucial, and Steen expressed this by means of glances, gestures and poses, all of which he could depict in a truly lifelike way.

8

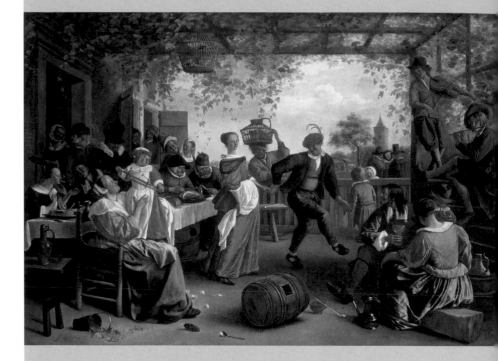

Ill-Matched Dancing Partners
A country lad has asked a smartly dressed city girl to dance with him outside an inn; a motley company of merrymakers watches the couple dance. Wearing a beret with a plume of cock's feathers, he cuts a comical figure, dancing exuberantly with a broad grin on his face. The girl looks uneasy and bashful compared to the youth. Drink flows freely here, and she might have had some of it, or she would never have agreed to dance with this country bumpkin in the first place. The poultry seller, who watches the dancing couple from behind, emphasises with his sly grin the indelicate nature of what is taking place here: the difference in standing between the two — and what might easily happen in such circumstances — was undoubtedly a source of great amusement.
Steen also portrayed the supporting actors with a feeling for anecdotal detail. A lot of flirting is going on around the table, but amid it all, a mother holding a toddler with a toy on her lap observes her child as it turns to watch the dancing couple. In the right foreground, a woman wearing a gleaming greenish blue dress sits with her wine-drinking companion; Steen tended to use such a figure, seen from the back, to draw the viewer's eye into the picture. Here this figure partly conceals a boy blowing bubbles, who functions as a moralising footnote to the scene — 'Homo bulla' — for despite appearances, a human life can burst at any moment, just like a soap bubble. In the work of Jan Steen, edification and amusement go hand in hand.

Jan Steen
The Dancing Couple, 1663
Canvas, 102.5 × 142.5 cm
National Gallery of Art, Washington
Widener Collection

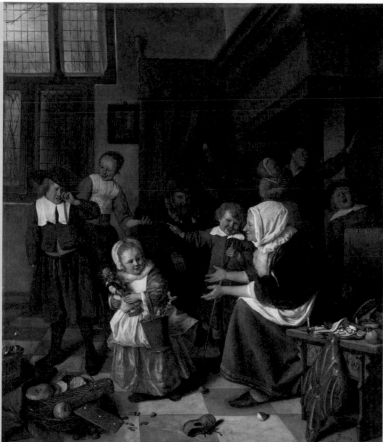

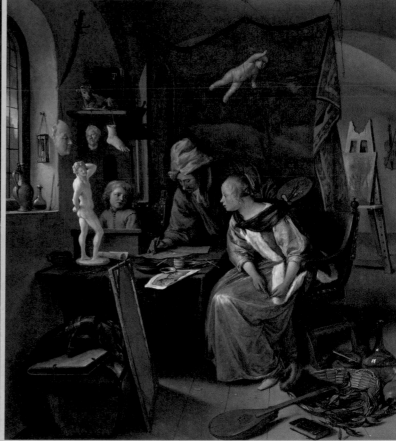

St Nicholas

Here we see Steen the painter-cum-storyteller at his best. Even today, Dutch people recognise every important feature of this holiday: putting out one's shoe at night (always in hopes of finding it filled with a present or sweets the next day), singing around the hearth, the teasing, the presents, the sweets and the rod for the naughty child. The little girl has been given a wooden John-the-Baptist doll and a bucket full of sweets, while her youngest brother, who received a 'kolf' stick, gloatingly points at an elder brother, upset because he found a rod in his shoe. He hasn't yet noticed his grandmother, beckoning to him in the background, where she probably has a present for him after all, hidden in the bed. On the right, three children sing by the fireplace; the smallest, in the arms of an elder brother, clutches a typical St Nicholas gingerbread. The still-life details are beautifully painted: the lone shoe, which plays such an important role in the ritual, the pewter bucket and the girl's doll, the wicker basket full of sweets and the festive, diamond-shaped bread leaning against the Renaissance seat in the right foreground.

Jan Steen
The Feast of St Nicholas, c. 1665/68
Canvas, 82 × 70.5 cm
Rijksmuseum, Amsterdam

An Ode to Painting

A painter has left his easel for a moment to correct the drawings made by his pupils: a boy and a young woman sharpening her pen. Various drawing materials lie on the table, as well as a plaster cast probably placed there for the pupils to draw. Leaning against a chest in the foreground is a stretched canvas, ready for them to use when they have progressed that far. On the shelf above the boy's head stands a statuette of a bull, the attribute of Luke, the patron saint of painters. The scene offers an abundance of meticulously rendered motifs, which together form an allegorical ode to the foundations of painting. No pure still lifes by Jan Steen are known, but here, in the right foreground, he enriched the scene with a masterly encore: a vanitas still life. Both its execution and its complicated subject matter make this a particularly ambitious painting. According to one of Steen's biographers, Jacob Campo Weyerman, Steen was very interested in painting theory, and it was a joy to witness his reflective discourses 'on all the characteristics of that art'.

Jan Steen
The Drawing Lesson, c. 1663/65
Panel, 49.3 × 41 cm
The J. Paul Getty Museum,
Los Angeles

Temptresses

Jan Steen painted a wide range of subjects, but he also had clear preferences, one of which was attractive women. A beautiful example is *'The Oyster Eater'* (p. 33), who is actually not eating oysters. Instead, she sprinkles salt on an oyster and offers us this morsel, known as an aphrodisiacal, with a smile. No doubt her gesture was meant to be ambiguous. Steen painted countless scenes with young women who refer to love or eroticism in all kinds of ways: lovesick girls, who yearn for their beloved; deceitful ladies who con their bedazzled admirers; women who drink too much and forget their morals. The hints Steen incorporates in his compositions vary from subtle to blatant.

In Steen's paintings it is often the temptresses, more so than the other characters, who draw attention to themselves. They catch the light, and are executed in greater detail and with more care. Their costly and colourful clothing is depicted with great sensitivity for the rendering of materials. Using painterly means that range from sketchy to refined, Steen guides the eye of the viewer to the important parts of the painting, which, more often than not, are attractive women.

Jan Steen
The Card Players, c. 1660
Panel, 45.5 × 60.5 cm
Private collection

In a beautifully depicted interior, a young woman cheats at cards. Her opponent is a military officer, who has already surrendered his sword to her. This weapon now dangles from the back of her chair. Her look of complicity is directed at the viewer, and our view of her concealed card makes us accessories to her deceit. A soldier who is tempted by a woman's charms to neglect his duty, to the point that he lets himself be disarmed, was a well-known theme, which Steen developed here into an elaborate composition. Our attention is immediately drawn to the woman in the foreground, who shows us the ace of hearts she holds by her side. Painted in meticulous detail, she catches the light, whereas other personages in the room are depicted in partial shade.

Jan Steen
Fiddling the Fiddler, c. 1670/72
Panel, 39 × 49.5 cm
Private collection (on loan to Stedelijk Museum De Lakenhal, Leiden)

An older man in fool's garb — holding a fiddle and a phallic pipe — good-naturedly lets himself be fiddled out of his money by a young woman, while an old crone (a procuress type) reaches over his shoulder to hand him a glass of wine. Amusingly, Steen himself plays the part of the duped fiddler: an old rake ruled by his passions and fooled by an attractive young woman. Obviously nothing good can come of this ill-matched couple. In this painting, executed with loose, unerring brushstrokes, Steen breathed new life into a traditional subject, devoting a great deal of attention to the interplay of the figures' faces and hands.

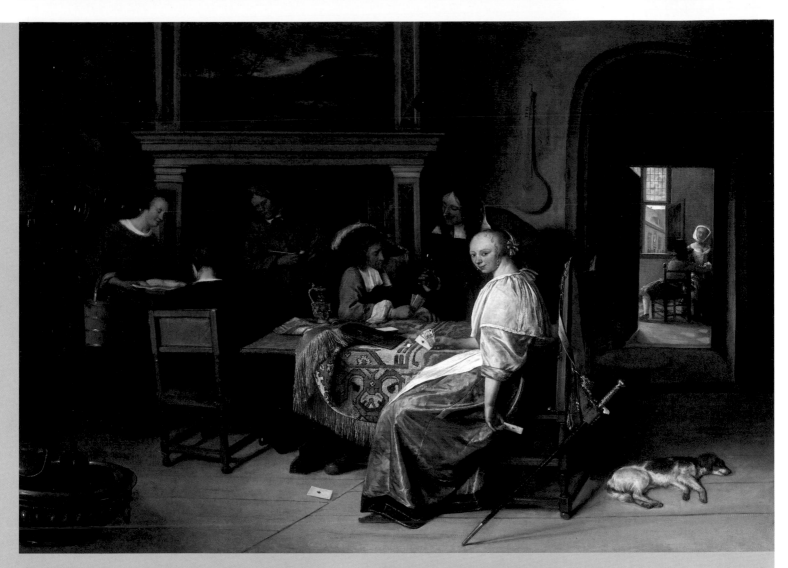

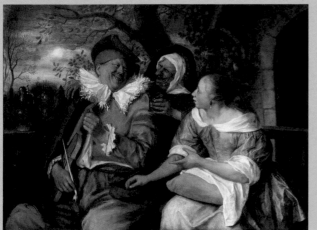

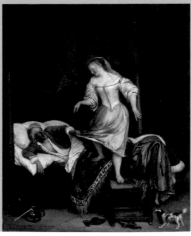

Jan Steen
Couple in a Bedroom, c. 1671
Panel, 49 × 39.5 cm. Museum Bredius,
The Hague

A partially undressed woman wobbles
precariously between chair and bed.
An older grinning man pulls her
towards him in the bed by the hem of
her petticoat. Her outer garment hangs
over the back of the chair. The pipe
propped on the edge of the chamber
pot probably symbolises the old Dutch
proverb 'to clean out one's pipe' (*een
pijpje uitkloppen*), which meant 'to visit
a brothel'. Seldom are the sexual
overtones as explicit as they are in
this rollicking picture by Jan Steen.

Proverbs

Nowadays, people who pepper their speech with proverbs sound like old fogies and run the risk of not being taking seriously, but things were different in the sixteenth and seventeenth centuries. Then, proverbs — which proclaim edifying or moralising truths in a clever and amusing way — were exceptionally popular, and were considered useful educational tools. Jacob Cats, the well-known moralising writer who in 1632 published an illustrated book of proverbs called 'Mirror of Old and New Times' (*Spieghel der ouden en nieuwen tijdt*), emphasised that proverbs — 'trusty teachers of life's path' — should preferably have double, or even multiple, meanings. Playful ambiguity and humour were rated highly in proverbs, as expressed by the classic motto 'ridendo dicere verum': to laughingly tell the truth.

The earliest portrayals of proverbs in the visual arts of the Low Countries are found in the marginal decorations in late-medieval manuscripts and in tapestries. The popularity of the genre was given a great boost, however, by the work of Pieter Bruegel the Elder, whose famous and much-copied *Netherlandish Proverbs* of 1559 portrays more than 120 such sayings. Seventeenth-century Flemish artists such as Sebastiaan Vrancx, David Teniers and Jacob Jordaens followed in his footsteps; in the Northern Netherlands, Bruegel's followers included Jan Steen and Adriaen van de Venne, the illustrator of Jacob Cats. No wonder that Steen loved to depict proverbs, given his fondness for puns, witticisms, anecdotes and jokes.

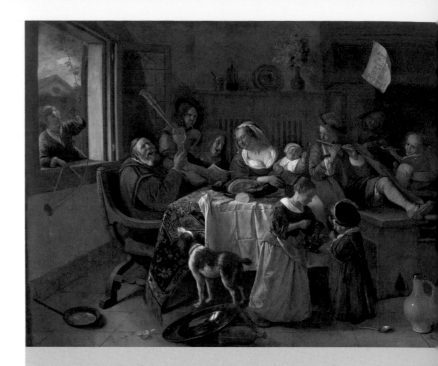

As the Old Sing, So Twitter the Young
Jan Steen portrayed 'As the old sing, so twitter the young' more than any other proverb. In this painting of 1668, the saying is written on a piece of paper pinned to the mantelpiece. This merry scene, which features children smoking and drinking in imitation of their undisciplined parents, warns of the consequences of a bad upbringing. Nevertheless, the proverb can be interpreted in more ways than one. In Jacob Cats's 'Mirror of Old and New Times', it is grouped with related proverbs under the caption 'cat after kind', meaning 'a chip off the old block' (*'t Wil al muysen wat van katten komt*). It is in a cat's nature to chase mice, and humans also do what comes naturally. Seen in this light, a child's upbringing has no influence on its development, because 'nature' will inevitably prevail over 'nurture'. Such toying with double meanings was an attractive aspect of proverbs, whether expressed in words or visualised in a painting like this one.

Jan Steen
As the Old Sing, So Twitter the Young, 1668
Canvas, 110.5 × 141 cm
Rijksmuseum, Amsterdam

'In Luxury Beware'

The mistress of the house is neglecting her duties. She has dozed off, and the result is riotous behaviour, degenerating into chaos. This dissolute household is named after the proverb written on a slate at the lower right: 'In weelde siet toe' ('In luxury beware'). In other words, extravagance can lead to rack and ruin. This is obvious from the rampaging children and house pets, as well as from the disgraceful behaviour of the young couple in the foreground. The man has shamelessly slung his leg over the woman's knees, while the woman, in an equally explicit gesture, holds her wineglass in front of his crotch. An older couple — the man is a quack, symbolised by the duck on his shoulder — try in vain to restore order.

Here Steen did not limit himself to a single saying but — following Pieter Bruegel — included a whole arsenal of proverbs. Considerable knowledge and intuition is necessary to unravel every thread of this overcrowded picture. In 1663, when the painting was made, such an elaborate composition with countless motifs was already old-fashioned. Usually Steen confined himself to portraying one proverb at a time.

Jan Steen,
'In Luxury Beware', 1663
Canvas, 105 × 145 cm
Kunsthistorisches Museum,
Vienna

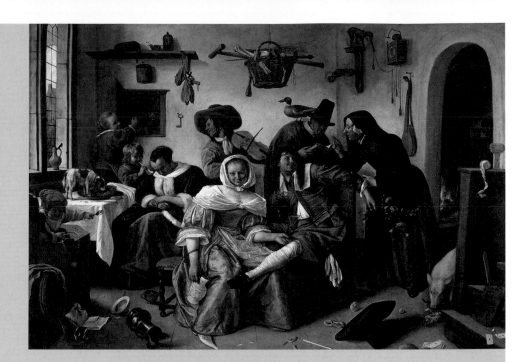

'Easy Come, Easy Go'

A laughing man — with the features of Jan Steen — sits at a table in a sumptuous interior; an attractive lady hands him a glass of wine, while an old woman prepares oysters (a well-known aphrodisiac). The inscription on the mantelpiece reads: 'Soo gewonne, soo verteert' ('Easy come, easy go'). Presumably the man is squandering his takings from the game of tric-trac (an old variety of backgammon), which is being played in the room at the back. To underscore the message, the richly decorated mantelpiece boasts a statue of Dame Fortune, standing with one foot on a die and holding a wind-vane in her hands. There can be no doubt about the meaning of this motif. What the boy in the foreground is doing is less clear, however: is he topping up the jug, or adding water to the wine? In the latter case, he would embody temperance. But no matter what he signifies, the lad's endearing face and tousled hair look extremely lifelike. It is such keenly observed details that make Steen's paintings fun and engaging.

Jan Steen
'Easy Come, Easy Go', 1661
Canvas, 79 × 104 cm
Museum Boijmans Van Beuningen,
Rotterdam

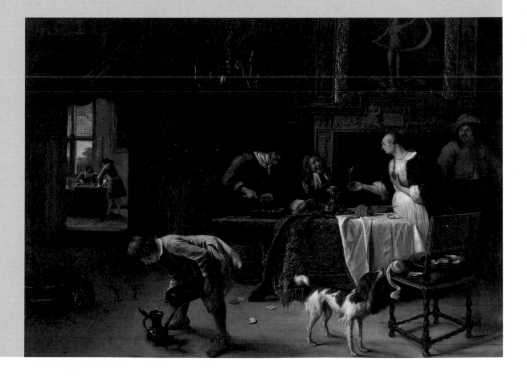

A Jan Steen Household

In a 'Jan Steen household' everything is in a shambles and everyone does exactly as he likes. Countless proverbs and sayings have fallen into disuse, but this expression — which presumably arose in the eighteenth century — is still in use. It was thought, almost from the beginning of his career, that Steen's farcical scenes reflected his own life. 'In general I must say that his paintings resemble his way of life, and his way of life resembles his paintings.' This is how Arnold Houbraken summed up the 'comical life' of Jan Steen in his three-volume lexicon of painters, published between 1718 and 1721. Houbraken sprinkled Steen's biography with anecdotes, in which the painter is portrayed as a joker and a guzzler. Because of Houbraken, Steen's life and work were long thought to be interchangeable.

Countless paintings by Steen portray human vices and frailties in every possible comic variation, or topsy-turvy worlds, as seen in his depictions of the proverb 'As the old sing, so twitter the young'. Seldom, however, is the dissolute household itself the subject, as it is in this painting, where a slate in the left foreground bears the inscription 'bedurve huishouw' ('dissolute household'). Here everything goes wrong. The mother, drunk and asleep with her head on the table, is being robbed by her children. Her husband has gone courting, having slung his leg over the thigh of a loose woman, who brazenly fondles his crotch. The maidservant is becoming involved with the fiddler; the dog is eyeing a large piece of meat; and a monkey that has climbed atop the four-poster bed stops the clock ('fools forget the time'). Spilling out of the tub hanging from the ceiling are objects that refer to the poverty that will result from such behaviour: matchsticks, a beggar's staff and a leper's clapper.

Jan Steen
The Dissolute Household, c. 1668
Canvas, 80.5 × 89 cm
Wellington Museum,
Apsley House, London

'Life in the Brewery'
There is another saying connected with Jan Steen, even though it does not mention his name: 'life in the brewery' ('leven in de brouwerij'). Houbraken recounts that when Steen's wife complained that the brewery did not provide them with a life (i.e. livelihood), Steen promptly filled a large kettle with water and malt, put in a couple of ducks which immediately flew every which way, and said: 'Now there's enough life in the brewery, isn't there?' This is typical of the kind of stories that were told about Jan Steen.

Many motifs in this painting also occur in *'In Luxury Beware'* of 1663 (p. 13).

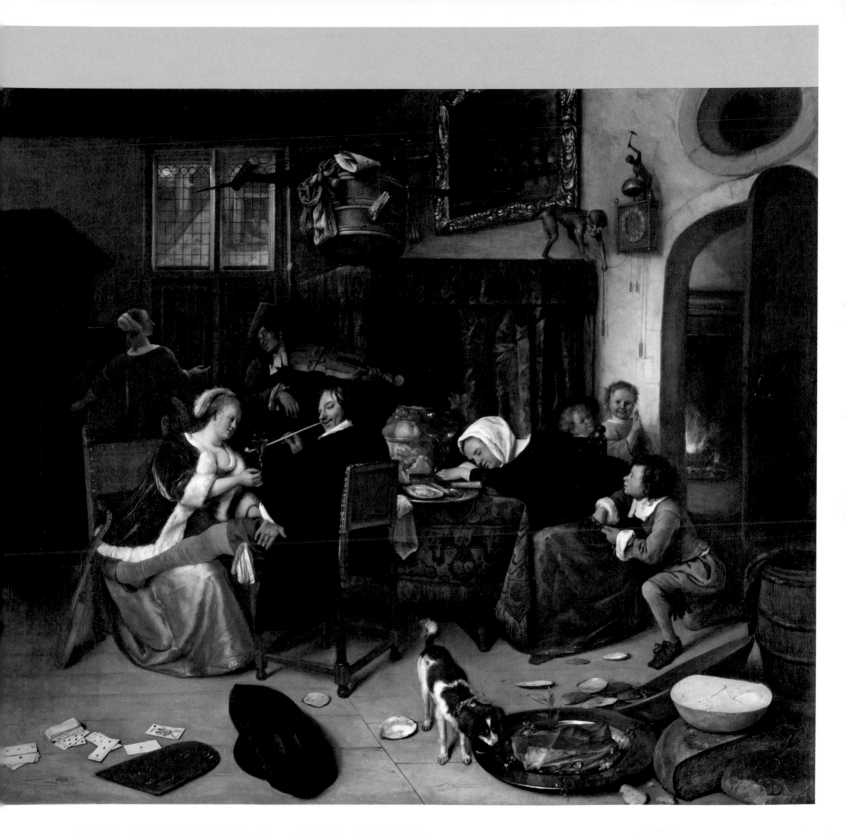

Jan Steen Plays a Role

No painter appears in his own paintings as often as Jan Steen does. He plays a role, for example, in both versions of the proverb 'As the old sing, so twitter the young' owned by the Mauritshuis. That the features of the laughing man with his fat cheeks, beady eyes and knobbly nose are those of Steen himself is confirmed by a traditional *Self-Portrait* (p. 7). In this painting he actually portrayed himself according to the conventions of portraiture, as a gentleman in contemporary dress turning his head to give us a serious look. In his *Self-Portrait as a Lutenist* — the only other individual self-portrait — Steen is decked out in an actor's costume and his face displays the well-known grin. Here, as a comic character, he is the protagonist for once, whereas his usual role is that of supporting actor, a figure whose perpetual laugh emphasises the satire of the scene as he mocks himself and the other characters too. Grinning broadly, he plays the role of the fool who lets himself be hoodwinked, or the father who sets a bad example for his children, or a kind of commentator, glossing the action for the benefit of the viewer. Just how often Steen appears in his own paintings is not entirely clear: sometimes his face is easily recognisable; at other times there is no more than a vague resemblance.

16

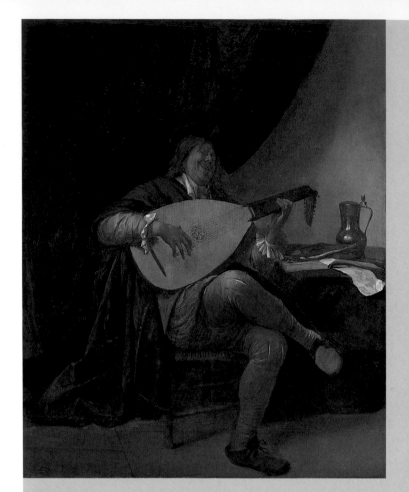

Jan Steen
Self-Portrait as a Lutenist, c. 1663/65
Panel, 55.3 × 43.8 cm. Museo Thyssen-Bornemisza, Madrid

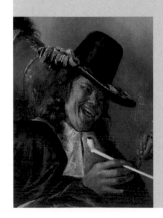

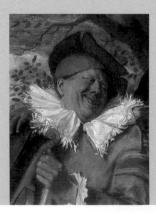

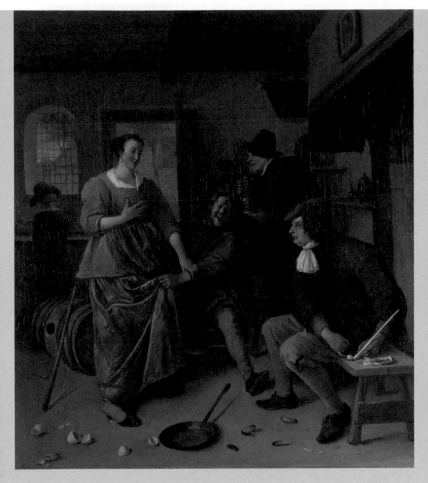

Jan Steen
Interior of an Inn ('The Broken Eggs'), c. 1664/68
Canvas, 43.3 × 38.1 cm. The National Gallery, London,
Bequeathed by Sir Otto Beit, 1941

In this *Interior of an Inn*, Steen plays the part of the
lecher, laughing as he lifts the woman's skirt. The
picture is full of obscene allusions and jokes, such
as the long-handled pan and the egg shells on the
floor, which refer to the Dutch expression 'throwing
eggs in the pan', a synonym for copulation. The
gesture of the man on the right, who sticks his
little finger into the bowl of his pipe, could carry a
similar meaning. The fact that Steen cast himself in
such an unedifying role makes the scene especially
amusing. Here there is no sign of a moralising
undertone.

Jan Steen
The Doctor's Visit, c. 1663/65
Panel, 46.3 × 36.8 cm. Philadelphia Museum of Art,
John G. Johnson Collection

Flashing a dirty smile at us, a man with the
features of Jan Steen holds up a herring and two
onions — a blatant reference to the male member
— next to a lovesick girl. If the patient wants to
recover, she must sleep with her beloved as soon
as possible.

Detail of '*As the Old Sing, So Twitter the Young*', p. 51
Detail of *Fiddling the Fiddler*, p. 11
Detail of *As the Old Sing, So Twitter the Young*, p. 57

History Painter

Belying his later image as a joker, Jan Steen was a versatile and ambitious artist with a great knowledge of literature, which proved especially useful to him as a history painter. He portrayed a wide range of subjects, many of them original, which he took from the Bible, the Apocrypha, classical mythology and history. These stories — which are full of excitement, drama, passion, and decisive moments of danger and reversal — are portrayed by beautifully dressed theatrical personages with carefully rendered gestures and facial expressions. As in his genre pieces, Steen focuses on the interaction between the figures, and has a keen eye for the humour inherent in every story. Steen's history pieces — some seventy paintings, most of which date from the 1660s — represent approximately one-sixth of his total known oeuvre. His unbridled ambition and passion for experimentation are illustrated by the fact that he painted most stories only once, and that he often chose unusual episodes from those stories. This is true of *Moses and Pharaoh's Crown* of around 1670, which depicts an apocryphal story from the infancy of Moses.

Medieval (illustrated) retellings of the Bible and the traditional commentary to the Torah offer an explanation of the brief statement in Exodus (4:10) that the prophet was 'slow of speech'. Moses, who had been adopted by Pharaoh's daughter, was three years old when, one day while playing, he ended up with Pharaoh's crown on his head. He threw the crown to the ground and trampled on it — all because of a statue of Jupiter (or another pagan god) that was attached to it. Pharaoh's counsellors, infuriated, recognised the child who was prophesied to destroy the kingdom of Egypt. Some of them wanted to kill Moses immediately, but others persuaded Pharaoh to give him one more chance. Moses was given a pan of burning coals and a dish of food (according to Jewish tradition, a dish full of gold); the child proved his innocence by choosing the coals and putting one in his mouth — an act that supposedly caused his speech impediment.

Jan Steen
Moses and Pharaoh's Crown,
c. 1670. Canvas, 78 × 79 cm
Private collection (on loan
to the Mauritshuis)

The trampling of Pharaoh's crown was occasionally depicted in seventeenth-century painting, but Steen chose instead to render the outcome of the incident: the crying Moses seeks refuge in the arms of his foster mother, and puts one hand to his burned mouth to explain why, as it says in Exodus, he was 'not eloquent'. In this way Steen knits together in highly original fashion the threads of this complicated story, which is known from various sources. Behind the child's back, the broken crown, the money-bag with gold coins and the pan of burning coals testify to what has just taken place. Steen portrayed the story as an amusing farce, paying much attention to Pharaoh's chagrin, the vexation of his shady advisers and the toddler's distress. A humorous detail is the little lion dog on the right, looking at us from the corner of its eye: a small court jester showing its red tongue and wearing a collar with bells.

18

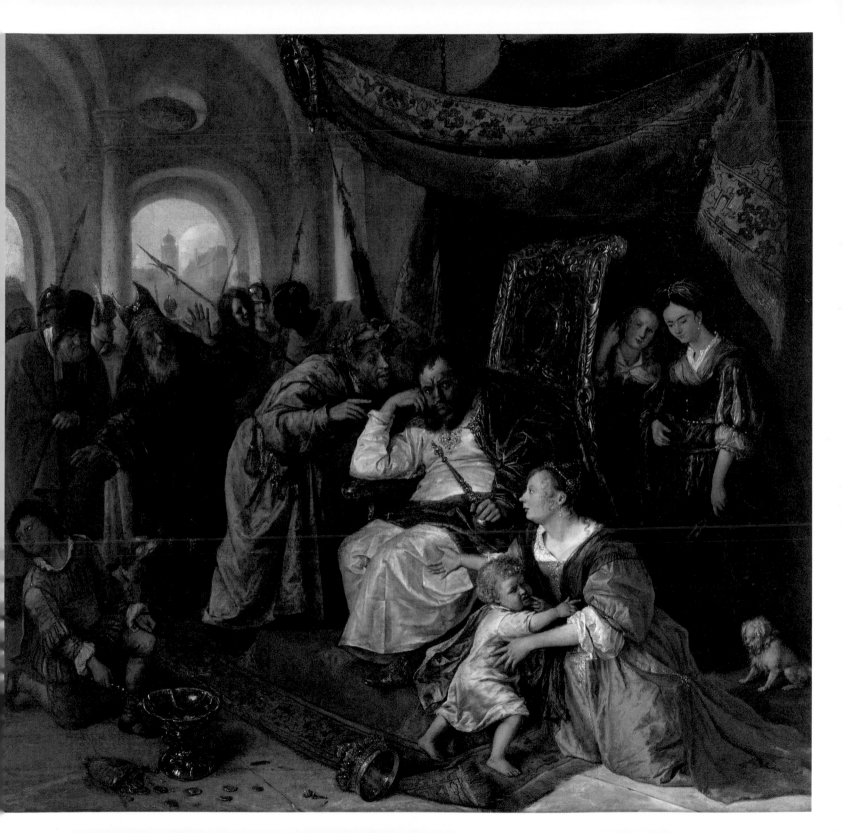

Expertly Painted

The main figures in this warm-hued picture — Moses, his foster mother and Pharaoh — immediately catch the eye because of the gleaming satin they wear. Steen was a master at suggesting the shimmering gleam of the fabric, rendered with rapid back-and-forth movements of his brush. He also devoted a great deal of attention to the poses and facial expressions of the figures: Pharaoh, slumped on his throne, furrowing his brow and clutching his sceptre as he listens to what his adviser whispers in his ear, and Moses' kneeling foster mother, who presses the frightened child to her breast while making an imploring gesture with her right hand. A real eye-catcher is the delicately painted profile of Pharaoh's daughter, which stands out lightly against the dark background. Steen applied pastose highlights to accentuate the gold crown, the brass brazier of burning coals and the gold coins spilling from the bag on the floor. He deliberately painted the supporting actors much more schematically and in a darker palette, thus placing them more in the background, both literally and figuratively. Steen used different degrees of finish in his painting to guide the viewer's gaze to this or that element. The quality of this work also emerges from his painstaking characterisations of the secondary figures, such as the priest with his upraised hand and the servant who turns his head away from the heat of the burning coals.

Two things that Steen worked out in exquisite detail are the carpet that serves as a baldachin above Pharaoh and the one on the floor, beneath his crown. By using small dots of pastose paint placed next to and above one another, Steen suggested the weave of the fabric in the parts nearest to the viewer, as seen in the upturned corner of the carpet near Moses' little feet. By rendering the more distant parts in less detail — slightly out of focus, so to speak — Steen created a convincing sense of depth.

Unique Drawing

Jan Steen was an extremely productive painter, but as far as we know, he hardly ever drew. Only two of his drawings have survived: a two-sided figure study and a preparatory sketch for *Moses and Pharaoh's Crown*. On the whole, the composition of this wash drawing is the same as the painting, but the accessory detail is simpler and the space depicted is compressed. Only three figures appear in the left foreground and the servant holding the brazier is missing, so that the dog on the left is fully visible. The key-keeper whispering in Pharaoh's ear is clearly a different figure; an additional character appears behind Pharaoh's throne; and the little white dog on the right is lacking. Steen struggled a bit with the figure of Pharaoh: his upper body is drawn on another, cut-out piece of paper, which was pasted onto the drawing, evidently as a correction to the earlier version. In the drawing, Pharaoh stares at the floor, whereas in the painted version he looks at the viewer out of the corner of his eye. All these differences clearly show that the sheet is not a copy made after the painting, but a preliminary sketch, perhaps intended for the person who commissioned the work. In particular, the modelling of the main figures, executed with the brush, has a painterly quality that makes the attribution to Steen plausible. The almost complete lack of preserved preparatory studies or designs by Steen may have to do with his spontaneous manner of working. He designed his compositions directly on the panel or canvas, and did not hesitate to make adjustments or changes to his painting whenever he felt it necessary.

To the left of the crown Steen drew a statuette on the ground: the idol that had driven Moses to trample on the crown. This detail occurs only in the Christian sources of the apocryphal story (such as the *Speculum Humanae Salvationis*, an influential typological handbook from the fourteenth century). According to tradition, the statuette on the crown is comparable to the statues of pagan gods that miraculously fell down before Jesus during the flight of the Holy Family into Egypt. In various ways the story of Moses is tied to the history of salvation, in which the prophet is seen as a prefiguration of Christ. It is not clear why this detail is missing in the painting, but one guess is that Steen was acting on the wishes of a Jewish patron.

Jan Steen

Moses and Pharaoh's Crown
Pen and brown ink, grey-brown wash, over traces of red chalk, with large paper correction. 24.4 × 27.4 cm
Ashmolean Museum, University of Oxford

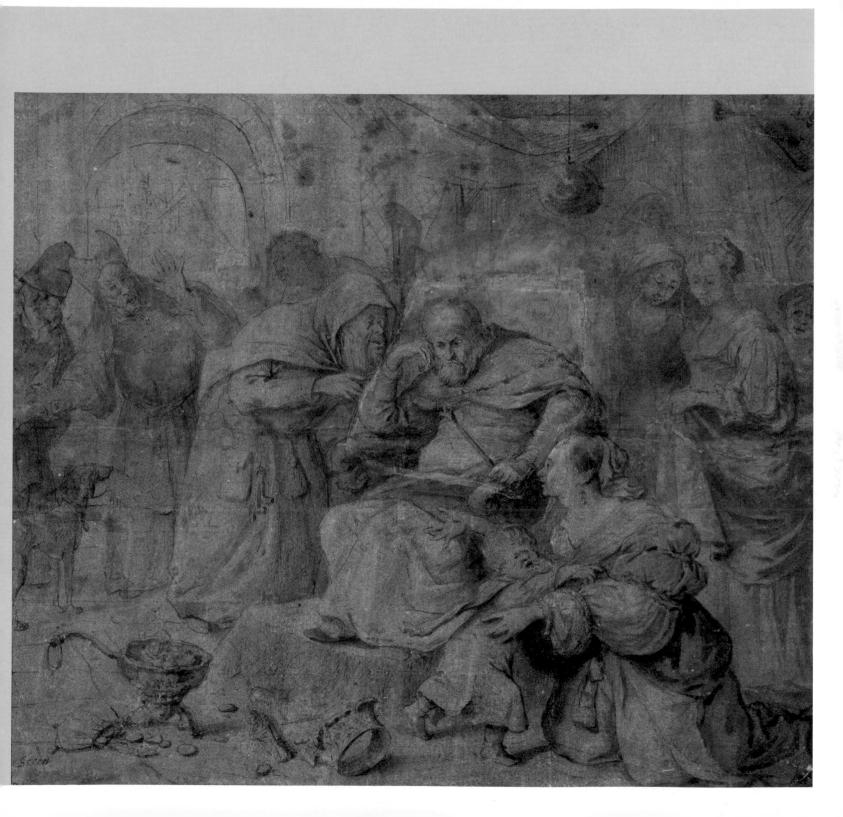

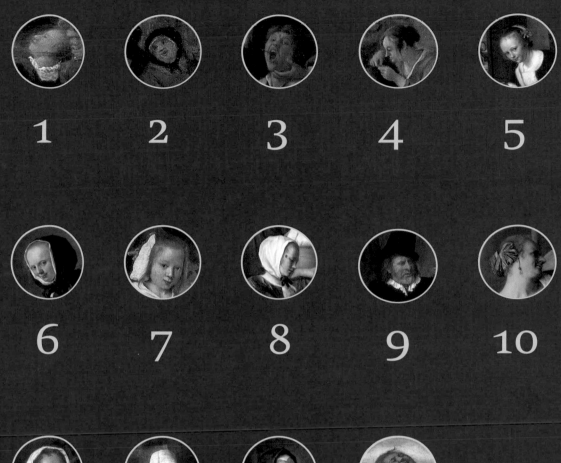

1 2 3 4 5

6 7 8 9 10

11 12 13 14

An Early Work

Observed by peasants drinking outside an inn, two couples dance in the round to the music of a fiddle, whose player stands on an empty beer barrel. The inn is accessible through an open door beneath a leaf-covered pergola propped up with a tree trunk. Steen depicted similar half-covered inn gardens more often, as he did circles of dancers. One of the dancing women turns to call out something to a couple of spectators, sitting on a bench, drinking. In the right foreground, a man tries to pull a woman onto the 'dance floor', but her companion keeps his arm firmly around her waist. On the left, a young man lies with his back to the festivities, sleeping off the drink. The scene is beautifully illuminated from the left by the low evening sun, which shines through the planks of the wooden fence. Steen not only captured the figures with a keen eye for detail, but also paid sufficient attention to the rendering of the trees and the dune landscape in the background. Infrared imaging has revealed that he prepared these elements of the landscape with a rapidly sketched underdrawing on the primed panel.

This painting is probably one of Jan Steen's earliest works. It seems to have come straight from the Haarlem studio of Adriaen van Ostade and his younger brother Isack, both masters of the peasant genre. According to the artists' biographer Jacob Campo Weyerman, Adriaen had been one of Steen's teachers. Following the Flemish artist Adriaen Brouwer, who worked for years in Haarlem, the Van Ostades made peasant scenes their specialism. Characteristic of Steen is his focus on the interaction of the figures, whose expressive poses he portrayed in a very lifelike way. A real peasant, for example, does not sit with his legs genteelly crossed, but leans inelegantly on one elbow, with his other hand clasping his knee.

Steen also seems to have studied the work of Pieter Bruegel the Elder, the patriarch of the peasant genre. *The Fair at Hoboken*, an influential print made after Bruegel's design, features the round dance as its central motif, but includes, behind the revellers, a group of pious people who have found the narrow path to the church. Who knows, but maybe Steen's lone horseman, making his way to the church in the distance, also has a deeper meaning.

24

Jan Steen
Peasants Dancing at an Inn
c. 1646/48
Panel, 38.5 × 56.5 cm

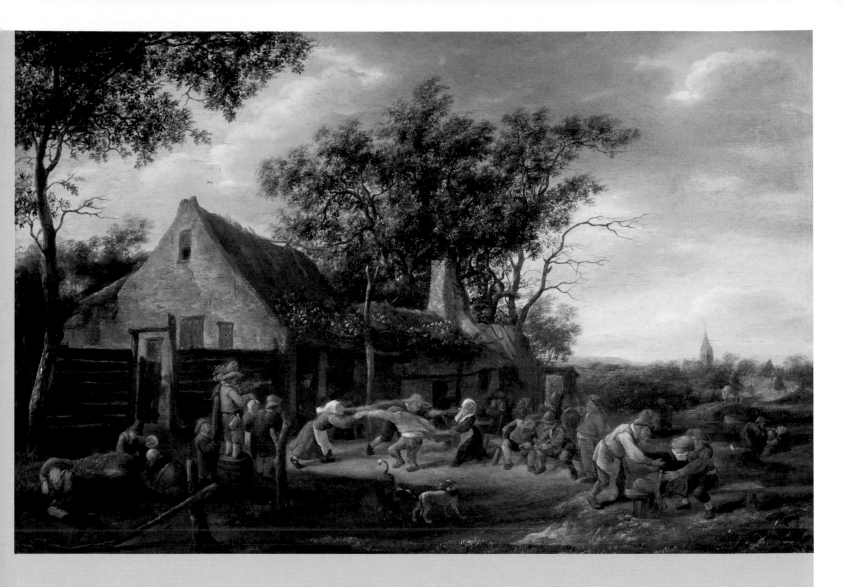

←

Unique Underdrawing

It is possible to penetrate the paint layers with an infrared camera and to expose an underdrawing on the ground. In this way we see that Steen made an underdrawing, presumably with black chalk, of the dune landscape on the right. He sketched the contours of the trees using curly strokes, and quickly drew a couple of short lines to mark the roofs of the buildings along the country road. The bridge, too, is indicated in the underdrawing, which he did not actually follow very closely while painting. A similar underdrawing has not previously been found in the work of Steen. Remarkably, its style of drawing is somewhat reminiscent of the work of Jan van Goyen, who became Steen's father-in-law in 1649. No underdrawing was detected in the figures.

Infrared image of *Peasants Dancing at an Inn* (detail)

Itinerant Quack

Amid the commotion of a village fair, a quack has erected a stage on which to demonstrate his arts to the gathering public. Large cloths act as backdrops and a rollable banner with painted figures serves to advertise the sham doctor, who has just pulled a tooth and holds it up for all to see. The victim of his medical maltreatment limps down the stairs on the right, pressing a cloth to his aching cheek. The quack shares the stage with a masked comedian, musicians and two monkeys, animals who 'ape' our silly behaviour. A farce is being played out in this painting: anyone who trusts such a 'doctor' must be very foolish indeed.

Keeping slightly aloof from the rest of the audience are two townspeople, illuminated by the sunlight falling on their backs from the left. This elegant couple leads our eye to the quack on stage. Townspeople visiting country fairs — where they could gape in wonder at the ignorant peasants — was a well-known theme in the visual arts and literature. It is a motif, for example, in the opening song 'Peasant Company' ('Boeren Geselschap') of Bredero's 'Large Songbook' (*Groot Lied-Boeck*). Steen drew inspiration more than once from the work of this poet and playwright.

This painting presumably dates from the early 1650s, when Steen was living in The Hague near his father-in-law, Jan van Goyen, whose landscapes did not exert a great influence on Steen's development. Although Van Goyen did draw a number of village fairs and markets, whose composition and choice of motif correspond closely to this *Village Fair* by Steen, it is difficult to know who looked over whose shoulder.

Jan Steen
Village Fair, c. 1650/51
Panel, 47.2 × 66 cm

Closely Related
The composition of this drawing by Jan van Goyen is closely related to that of Steen's painting; numerous motifs resemble one another. The figures in the left foreground, which are concealed in shadow, stand out as silhouettes against a wide, brightly lit patch, flooded by the sunlight that illuminates the scene on the right. A quack and a masked actor stand on the stage, marked by cloth backdrops and signboards. A monkey sits amid the 'medical' implements. As in Steen's work, the spectators include a horseman and a mother holding a small child.

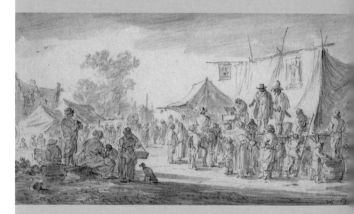

Jan van Goyen
The Yearly Market, 1653
Black chalk, wash, 11.5 × 20.5 cm
The Art Institute of Chicago

The Toothpuller

In the *Village Fair* you have to search to find the toothpuller's patient in the midst of all the commotion, but in this small painting of 1651 Jan Steen has zoomed in on him. He sits in the middle of the picture, his arms tied to the chair with a rope, his mouth wide open, and his face contorted with pain and fear. The quack-cum-toothpuller, wearing ridiculously old-fashioned clothes, already has the tooth in the grip of his tongs. The tension of the moment is aptly expressed by the patient's clenched fist and his raised leg with sagging stocking. The boy holding a hoop, who stands directly in front of the patient, risks getting kicked when the tooth is finally pulled (here Steen displays his mastery in depicting frozen movement). Like the other spectators, this boy stands as close as possible, so as not to miss any of the action. Laughing children mock the victim, who foolishly submits to the quack's treatment. An old woman, who wears a hooded cloak typical of the Northern Netherlands, is more concerned for the patient's welfare; she looks on worriedly, her hands clasped. The wicker shopping basket hanging on her arm identifies the location as a market, a suitable venue for quacks and other itinerant merchants hawking their wares.

Standing on a board atop an empty beer barrel — displaying the crossed keys of Leiden's coat of arms — are the sham doctor's pots and jars, as well as an official-looking document with a seal, a traditional motif in depictions of quacks and toothpullers. An engraving by Lucas van Leyden of 1523 — in which the patient is robbed by the doctor's accomplice while his tooth is being pulled — contains a similar certificate. 'The seal inspires confidence' is the motto of an emblem from Roemer Visscher's 'Emblems' (*Sinnepoppen*) of 1614, which is accompanied by a print of a document with a wax seal. The fact that the toothpuller needs such a pretentious document in order to gain the trust of his clients underlines his deceit all the more. The document bears a date (1651) and the inscription 'Carolus Com..'; a certain Count (Comes) Karel apparently issued the certificate. Steen focused attention on the document by painting it with extreme precision and delicacy, as he did the patient's face. Other passages — such as the most distant figures — were executed much more sketchily. Such a varied style of painting is typical of Steen.

Jan Steen
The Toothpuller, 1651
Canvas, 32.5 × 26.7 cm

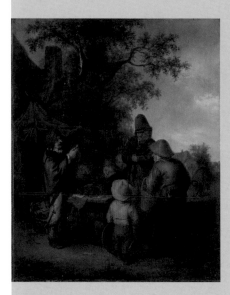

Adriaen van Ostade
The Quack, 1648.
Panel, 27.5 × 22 cm
Rijksmuseum, Amsterdam

Jan Steen obviously studied this composition by Adriaen van Ostade, from which he borrowed several motifs, such as the boy with a hoop, seen from the back, and the beer barrel supporting a table with the quack's certificate lying on it. Moreover, the two works are staged in a similar way: both scenes are set outside under the trees, with a tent in the right background. But there are also revealing differences: in contrast to Steen, Van Ostade pays scant attention to the action and the range of emotions betrayed by the figures. The humorous possibilities of the subject seem to have been lost on him.

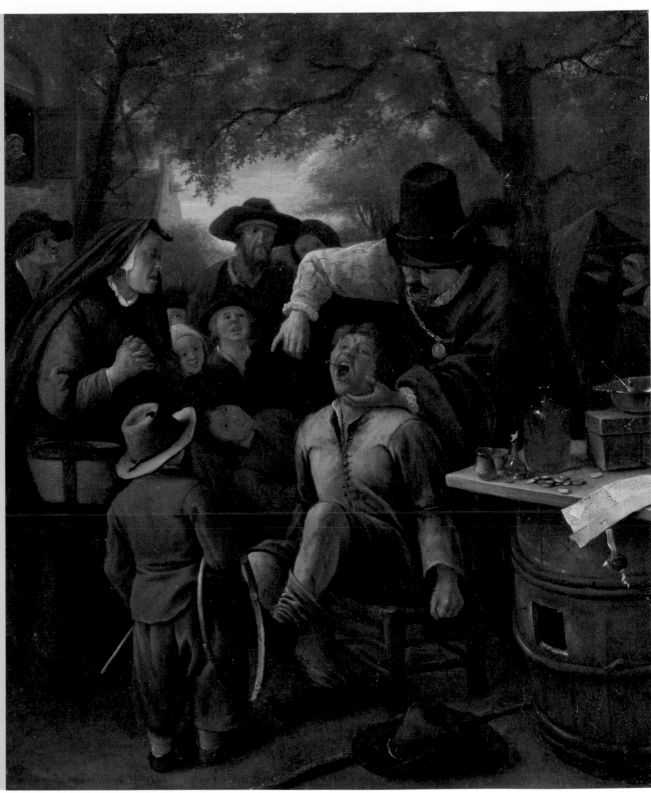

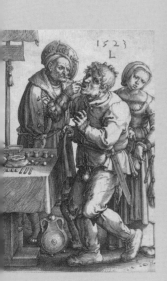

Lucas van Leyden
The Toothpuller, 1523
Engraving, 11.6 × 7.5 cm
Rijksmuseum, Amsterdam

'They've pulled one on me' ('Ze hebben me daer een getrokken'): thus reads an old Flemish proverb in which toothpulling stands for deceit and thievery. This print by Lucas van Leyden was the first portrayal of this theme: the victim is relieved not only of his tooth but also of his money. The tooth-puller sports a showy beret full of insignias; his competence is also attested to by an impressive document attached to a pole. The pathetic stupidity of the peasant who allows himself to be duped is underscored by his ragged clothing.

Young Lady and Fortune Teller

A young lady wearing an elegant, yellow satin dress and her companion, decked out in black, have gone to a nondescript place near a dilapidated vault where a group of vagrants have found shelter. There she has her palm read by a scruffy woman with a child propped on her hip and one breast hanging out of her dress; the man stands between them and watches from the corner of his eye as the fortune teller, whose open mouth indicates that she is speaking, predicts the woman's future. The other figures laze about, paying no attention to the couple: one sleeps, another plays the recorder; a woman delouses a child, while others tend a pot on the fire. One child offers freshly picked flowers to the fortune teller's baby. Clearly, the bourgeois couple does not belong here, and it isn't wise of them to get mixed up with such unsavoury types.

Fortune-telling, a well-known phenomenon in the seventeenth century, was seen in a bad light. The wise Sophronicus in Jacob Cats's 1637 love story 'The Spanish Heathen' (*Het Spaense Heydinnetje*) says: 'Asking the advice of fortune tellers or palm readers ... is clearly forbidden by both divine and human laws.' It was usually gypsies ('heathens') with half-naked infants who tricked gullible people into giving them money to predict the future. Portrayals of the subject sometimes emphasise the deceit by having the client's purse stolen for good measure. That is not the case here, but the contrast between the elegant lady and the slovenly fortune teller clearly shows that it's a mistake to get involved in such dealings.

Steen devoted a great deal of attention to the main figures, which he worked up in detail with a fine brush. He borrowed the young lady from the work of Gerard ter Borch, who is known for his refined interiors with elegant women and his talent for rendering gleaming satin. In the 1650s Steen drew inspiration for a time from this 'fine painter'. The still life in the lower left corner, which includes a tree trunk and a single red poppy among the vegetation, is beautifully depicted. A still-life element rendered in such detail in the foreground is typical of Steen's work.

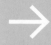

Jan Steen
The Fortune Teller, c. 1650/54
Canvas, 73 × 59.3 cm

Inspiration
Steen copied this young woman almost exactly from Ter Borch; even the folds in her dress are the same. Such an elegant young lady belongs, of course, not outdoors among vagrants but inside, in the company of a maidservant who helps her to dress. Steen used this quotation from Ter Borch to underline the contrast between his two protagonists.

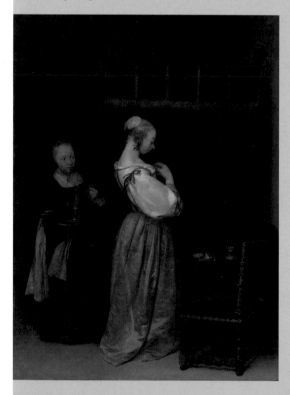

Gerard ter Borch
A Young Woman at Her Toilet with a Maid, c. 1650/51
Canvas, 47.6 × 34.6 cm
Metropolitan Museum of Art,
New York

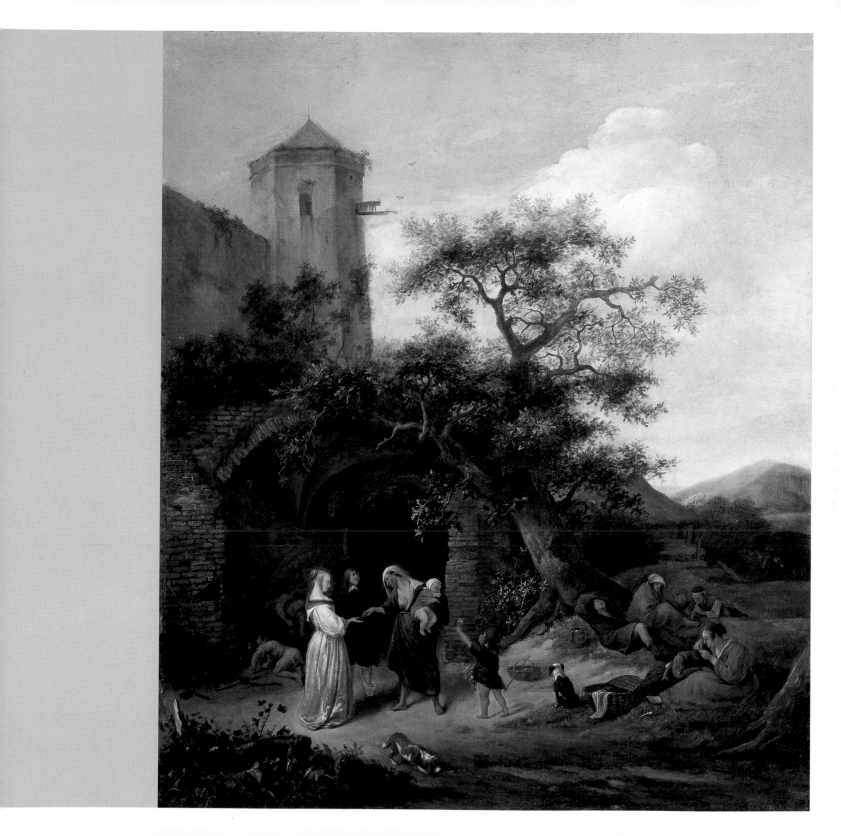

'Salty Oyster Juice'

This young woman looks at us sweetly as she sprinkles salt on an oyster. Lying before her on the table is a splendid still life consisting of oysters, a Delftware jug, a glass of white wine and a silver platter with a bag of pepper, some salt, a bread roll and a knife. In the kitchen in the background, two servants are busy preparing even more oysters.

Oysters were, and still are, believed to be an aphrodisiac, a food that arouses sexual desire. The physician Johan van Beverwijck described this delicacy in his popular medical handbook of 1651 as 'the most pleasing to the palate' of all the crustaceans, 'for they arouse the appetite and the desire to eat and to make love, both of which are pleasing to lusty persons of delicate tastes'. Jacob Cats warned against using 'love remedies', including 'salty oyster juice'. The girl thus seems to be offering the viewer herself as well as the oyster. An oyster is salty enough on its own, but the ample salt she sprinkles on it spices up the morsel and its suggestive message even more, since salt was also considered an aphrodisiac. The curtained bed in the background heightens the seductive atmosphere.

'The Oyster Eater' shows that Steen had completely mastered the art of 'fine painting'. All the fabrics and materials are rendered in lifelike detail, even though not a single brushstroke is visible; the soft velvet and the fluffy fur of her jacket, the skilfully tied ribbon in her hair, the reflections in the gleaming silver, the dull finish of the earthenware jug, the succulent oysters. This masterpiece — the smallest in Steen's oeuvre — rivals the best work of the Leiden 'fine painters' Gerrit Dou and his pupil Frans van Mieris. When Steen made this painting in 1658/60, he was probably living in Warmond, a village near Leiden.

32

Ambiguous Message
How seventeenth-century Dutch paintings — particularly genre pieces — should be understood has been a topic of discussion for decades, with interpretations varying from cautious to speculative. For a long time all attention was focused on the masters' lifelike ('realistic') manner of painting. Only in the 1970s did art historians return to the idea that the content of these paintings was as important as their form; the significance of *'The Oyster Eater'* lies not only in its fine execution, but also in its ambiguous message.

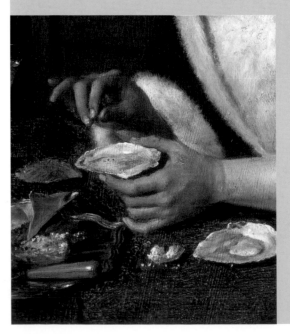

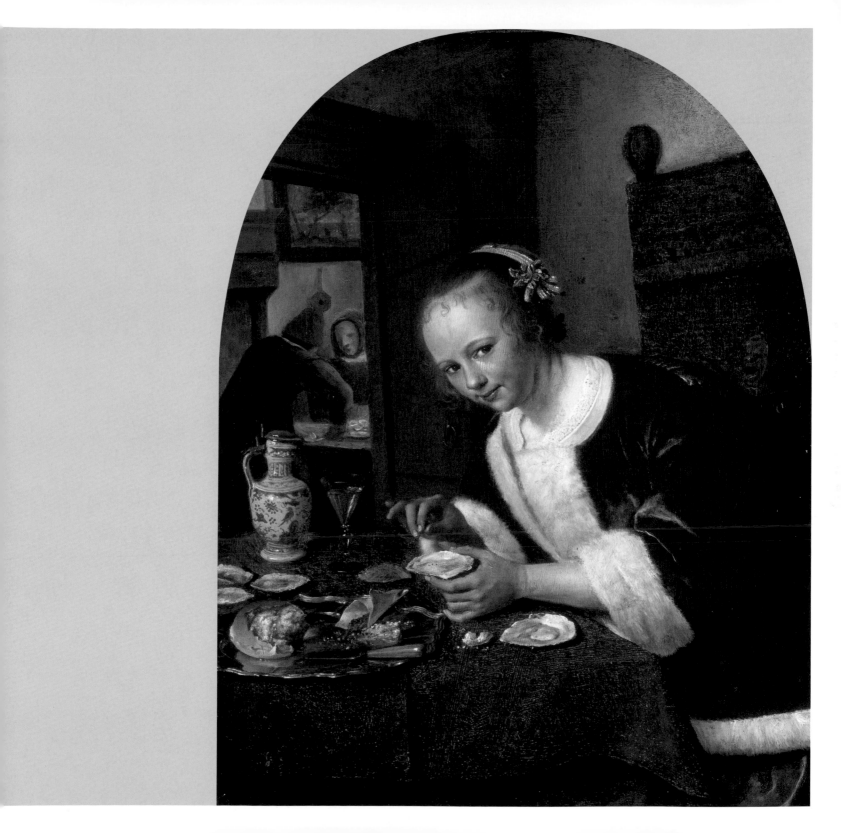

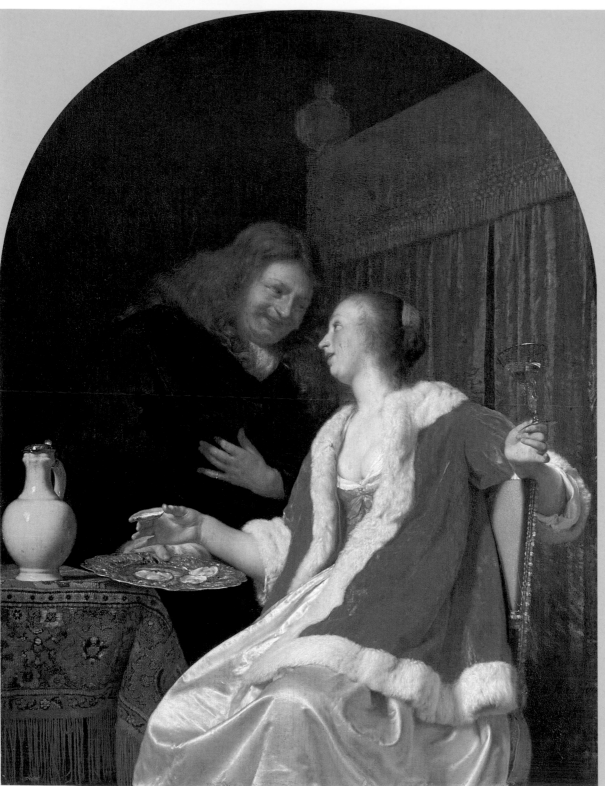

Frans van Mieris
The Oyster Meal, 1661
Panel, 27 × 20 cm. Mauritshuis

Oyster meals were a popular subject in seventeenth-century Dutch painting, because they offered such scope for suggestive allusions to love. Like Steen, Frans van Mieris painted oyster meals repeatedly. In this painting of 1661, a laughing man offers a plate of oysters to a young woman while staring deeply into her eyes. The woman evidently encourages his advances, since she already has an oyster in her hand. An amusing fact is that this man and woman display the features of Van Mieris and his wife, so how could she possibly reject his overtures? The painting demonstrates Van Mieris's talent for rendering different fabrics in a stunningly convincing way: the fur, velvet and satin of the woman's clothing tempt us to reach out and touch it. Van Mieris and Jan Steen, his senior by nine years, were good friends. We know this from Arnold Houbraken, the artists' biographer, who wrote that Van Mieris was very fond of Steen's brand of humour. For a while there was a certain amount of artistic rivalry between these two, during which time Steen seems to have drawn inspiration from Van Mieris's exceptional talent for 'fine painting'.

→

With the Tip of his Brush
Steen was a master at rendering a wide variety of materials, which seem to be painstakingly executed, but in fact were often painted with rapid yet unerring virtuosity. Using the tip of his brush, he could combine several colours without actually blending them, which produced the subtle effect of shot fabric.

Motifs

Jan Steen used certain motifs repeatedly in his work. He seems to have had a stock of examples that he drew upon for his compositions, without however succumbing to boring repetition. He had a small supply of dogs, for example, which crop up frequently in his work. Some faces, too, recur more than once, such as this girl with her high forehead, slightly protruding lower lip and pointed chin, who appears in several of his paintings, in which she holds her head in the same position and makes contact by looking the viewer straight in the eye.

Details from *'The Oyster Eater'*, *Woman Playing a Cittern* (p. 37) and *The Card Players* (p. 11)

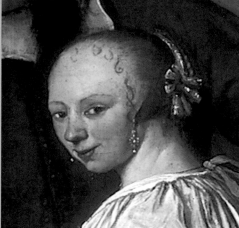

Direct Contact

This young woman looks at us with a coy smile as she uses a plectrum, held between the thumb and forefinger of her right hand, to strum her cittern. There is nothing to distract our attention from her face and agile fingers, for the background is a uniform grey. This complete lack of accessory detail — a rarity in Steen's oeuvre — makes the woman's gaze particularly compelling. Her look is comparable to that of another half-length figure, *'The Oyster Eater'*, who offers us an oyster she has just salted. Indeed, both of their smiling faces seem to be based on the same model, a woman with a high forehead and narrow chin. The woman playing the cittern has in fact been recognised as Steen's wife, Grietje van Goyen, although her face seems to be more of a general type that Steen used more often; the 'oyster eater', however, was never thought to be Steen's wife.

It does not seem far-fetched to assume that the girl holding the aphrodisiacal oyster is offering herself to us, given the suggestive motifs of the scene. But what are we to think of the woman playing the cittern and the way she glances at us? Is she inviting us to make music with her? Depictions of attractive young female musicians are often full of love symbolism, but here the interpretation is not immediately evident. Remarkably, no glimpse is to be had of the woman's chest and neck, which are completely covered by a high-necked shoulder cape of dark fur. Moreover, she wears a hood of the type generally reserved for Steen's old crones. Is the joke actually the contrast between this garment and the musician's flirtatious glance? Or does this attire actually have erotic undertones? The latter possibility is suggested by a well-known print by Wenzel Hollar of 1643, in which a young female personification of Winter is likewise cloaked in fur and wears a similar black hood. As the frank inscription reveals, her skin, thus protected from the cold, remains soft and pleasurable to embrace in bed. Is this also true of the cittern player? It is not always easy to understand how Steen intended us to see his pictures.

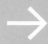

Jan Steen
Woman Playing a Cittern, c. 1662
Panel, 31 × 27.5 cm

Soft Skin
The inscription on this 1643 print by Wenzel Hollar reads: 'The cold, not cruelty makes her weare / In Winter, furrs and Wild beasts haire / For a smoother skinn at night / Embraceth her with more delight.'

Wenzel Hollar
Winter, 1643
Etching, 26 × 18.6 cm
British Museum,
London

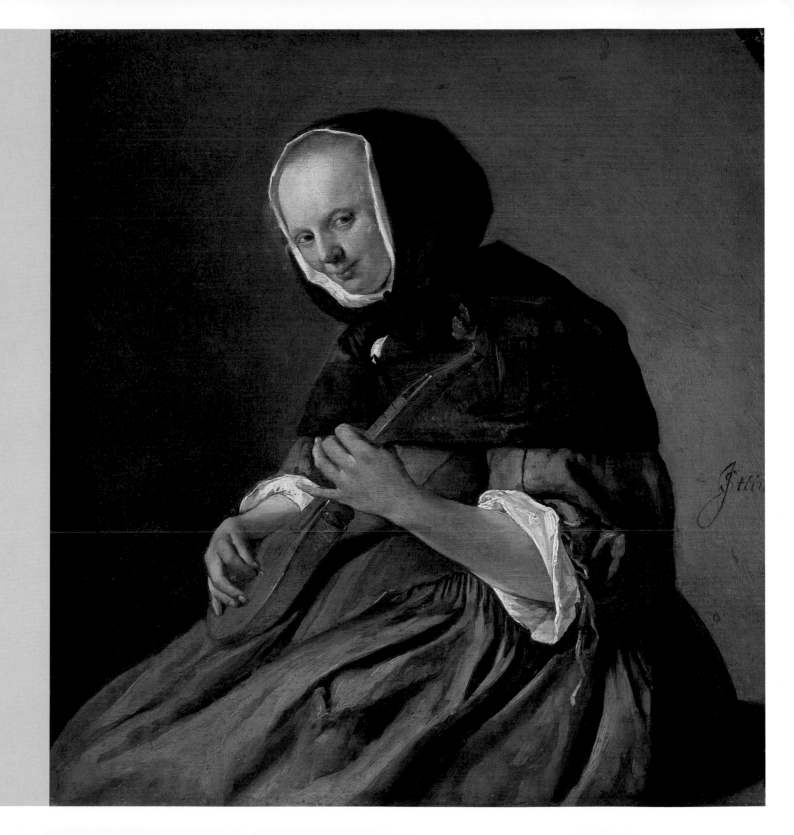

Heiress before her Castle

This exceptionally original painting of a girl and two servants in a poultry yard is a favourite of visitors to the Mauritshuis. Here Steen exhibits not only his gifts as a portraitist and genre painter, but also his talent for painting poultry. The child sits on a step in an enclosed yard, surrounded by a colourful throng of poultry: chickens, doves, fancy ducks, a cock, a turkey, a pheasant and an impressive peacock perched on the bare tree. Visible through the gateway is Lokhorst Castle, also known as Oud-Teijlingen, near Warmond. The girl wears a pretty yellow satin skirt and an immaculate white apron. Looking at the viewer, she feeds milk to a lamb. Her summery straw hat lies behind her on the step. An Italian whippet at her feet licks up the milk dribbled on the ground. The two servants, who both watch the girl, were probably entrusted with the care of the animals. Their faces are so portrait-like that we may assume that both men were members of the castle's staff. The balding man on the right, who holds the jug of milk, has collected the eggs and carries them in his basket and his tied-up blue servant's apron. On the left, the grinning dwarf with a tear in his coat — adding a comic note to this scene — carries chickens in a wicker basket and one under his arm.

The obvious contrast between the prim and proper little girl and her inferiors wearing such old-fashioned dress underlines their difference in status. She is, in fact, the heiress of Lokhorst Castle: Jacoba Maria van Wassenaer (1654–1683). In 1660, when Steen painted her, the six-year-old girl was living with her father, the widower Jan van Wassenaer, at Lokhorst, where she had been born. A stone set into the wall above the gateway displays the coats of arms of the girl's great-grandparents, Nicolaes van Mathenesse and Geertruyt Lockhorst, who had brought the castle into the family. Jacoba's father undoubtedly thought that his daughter would one day become 'Lady of Lokhorst'. That did not happen, however. After her marriage she moved away, but her childhood portrait stayed behind in Warmond, presumably until the castle's movable goods were sold in 1764. At that time the identity of the sitter was no longer known. (It was verified only recently.) For Jan Steen, who was living in Warmond in 1660, this must have been a prestigious commission, which connected him to a noble family of great consequence.

Jan Steen
Portrait of Jacoba Maria van Wassenaer, known as 'The Poultry Yard', 1660
Canvas, 106.6 × 80.8 cm

Overpainted Family Arms
Set into the stone above the gateway are the family arms of Nicolaes van Mathenesse and Geertruyt Lockhorst, the great-grandparents of little Jacoba Maria. For a long time, however, these coats of arms were invisible. After 1764 they were overpainted, presumably to make the painting easier to sell, since family portraits do not readily attract buyers on the free market. Stadholder William V bought the canvas in 1769 from an Amsterdam art dealer, possibly because he thought it portrayed a descendant of the House of Orange. When the painting was restored in 1948, the family arms reappeared.

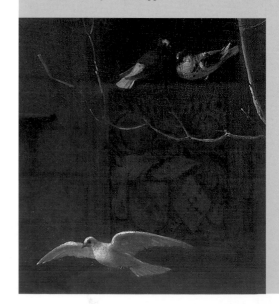

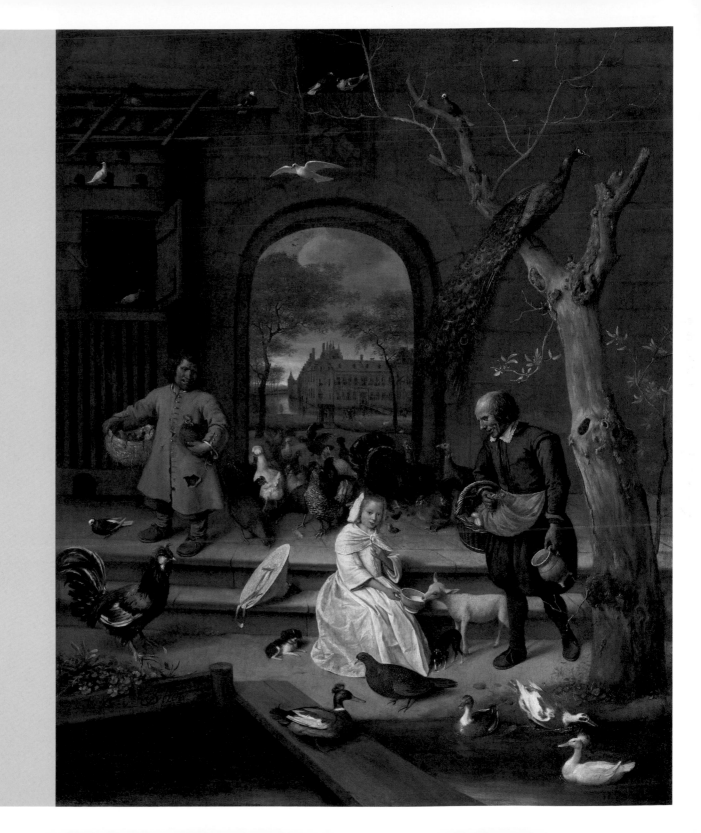

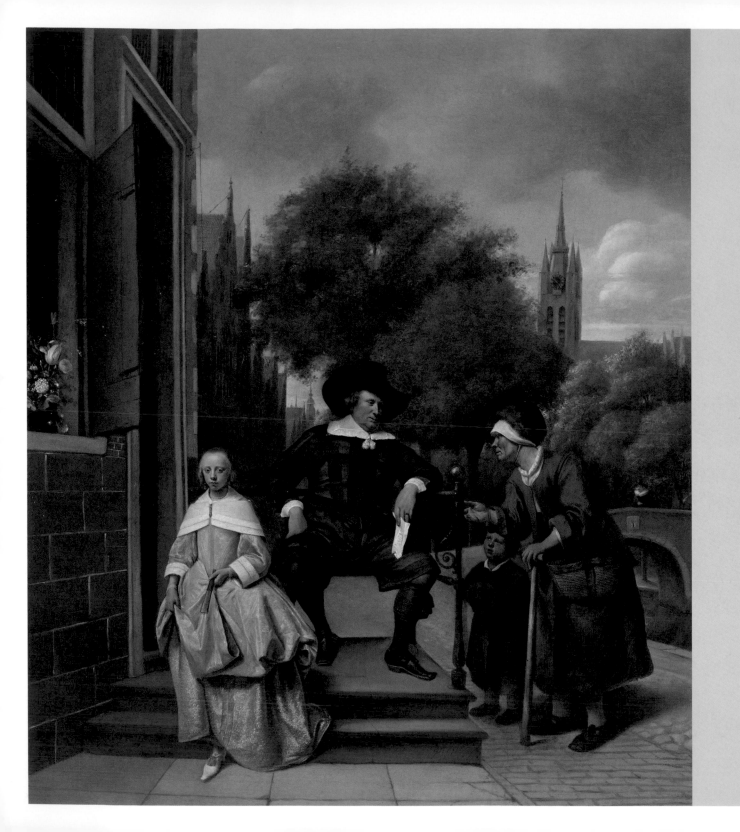

Jan Steen's Neighbours

Steen painted few portraits, but when he did, he made something very special. In 1655, five years before painting *The Poultry Yard*, he painted the portrait of this elegant girl. She, too, is portrayed in a topographically recognisable place: on the front stairs of her house on the Oude Delft canal in Delft. The tower of the Oude Kerk is visible in the right background. The girl's father sits rather nonchalantly in the centre of the picture, and is being addressed by a woman with a child. This woman and her child are obviously poor, and she seems to be begging. It is possible, however, that she is requesting another form of charity, and the letter in the gentleman's hand might be a document certifying her genuine need. The identity of the distinguished burgher and his daughter was discovered only recently. He turns out not to have been a burgomaster, as was always assumed, but a wealthy Delft grain merchant: the 43-year-old widower Adolf Croeser. His only child, Catharina, was thirteen in 1655; she looks at us while lifting her skirt to step down the stairs. The Croesers lived in a house on the west side of the Oude Delft canal. Opposite their house stood 'The Curry Comb' ('*De Roskam*'), the brewery Jan Steen operated from 1654 to 1657, while living in Delft. This father and daughter were therefore his neighbours. A striking detail is the beautiful bouquet of flowers on the windowsill next to the front door.

Like *The Poultry Yard*, this is an exceptional portrait, in which Steen gives ample proof of his versatility as a painter. It is not only a portrait of a distinguished gentleman and his fashionably dressed daughter, but also a genre painting and a townscape with a bonus: a small flower still life. In this work Steen combined various painterly techniques. The shiny satin of Catharina's skirt is delicately painted, as is the gleaming black of Croeser's suit. Their faces, moreover, are depicted with portrait-like precision. By contrast, the 'beggar woman' and her child are painted in much less detail.

Jan Steen

Portrait of Adolf and Catharina Croeser, known as 'The Burgomaster of Delft', 1655
Canvas, 82.5 × 68.6 cm
Rijksmuseum, Amsterdam

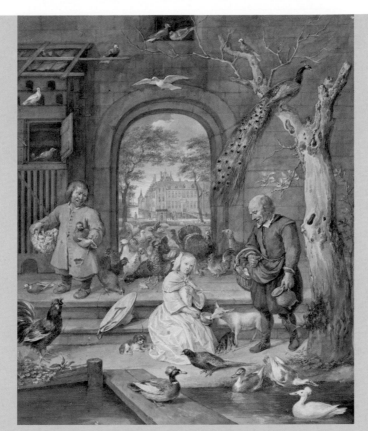

Aert Schouman after Jan Steen

Portrait of Jacoba Maria van Wassenaer, known as 'The Poultry Yard', 1774
Drawing, 41.6 × 33.1 cm
Eijk and Rose-Marie de Mol van Otterloo Collection

This drawn copy made by Aert Schouman in 1774 shows the painting as it was at that time, with the family arms overpainted.

Symbolism

Jan Steen's paintings are full of symbolic allusions. Some of them are relatively easy to interpret, but many are difficult to decipher, and our interpretations are far from certain. The bare tree with one strong new shoot could refer in this context to the nearly extinct Van Mathenesse-Lockhorst family, from which young Jacoba Maria was nevertheless descended. By the same token, the peacock could stand for immortality, but that is much less certain. It seems reasonable to think that in a child's portrait of this kind, the drinking lamb symbolises innocence.

Languid Young Ladies

One of Jan Steen's favourite subjects was 'the doctor's visit', or 'the sick girl': a picture of a languid young lady in her bedchamber, receiving the doctor. The patient lies in her four-poster bed or slumps weakly in a chair, only just able to hold up her arm for the doctor to feel her pulse. To make a diagnosis, he will need a urine sample, seen here in a flask on the table. From around 1660 onwards, Steen painted nearly twenty variations on this farcical theme. The tenor of these pictures is always the same, and would have been immediately clear to Steen's contemporaries: the patient is suffering from *furor uterinus*, a potentially life-threatening disorder that mainly afflicted young virgins. It was thought that this condition was brought on by sexual abstinence, which caused the uterus to be set dangerously adrift. The only effective remedy for women suffering from a 'wandering womb' was to marry quickly. Even though medical science took this disorder seriously, Steen was bent on showing its humorous side. It was also made much of in various contemporary plays, in which an infatuated girl was helped by her maidservant to feign the condition, in hopes of forcing her reluctant father to consent to her marriage. The dim-witted doctor is unaware, of course, that he has become an object of ridicule.

In Steen's paintings, the doctor, decked out in ludicrously old-fashioned clothing, invariably cuts a comical figure. Here his young patient lets him feel her supposedly weak and irregular 'love pulse', while a maid watches and another woman stokes up the fire in the sick room. A familiar motif is the pan of glowing coals and a smouldering ribbon, the smell of which was said to have a salutary effect on the womb. The lap dog — or cuddly toy, for lack of anything better — probably represents the absent lover. The meaning of the Cupid on the mantelpiece is perfectly plain: by holding high his love arrow, he clearly shows the only remedy for this lovesick girl.

This is an ambitious painting in which Steen's talent comes to the fore in his rendering of the complicated diagonal perspective, the shine and texture of the materials, and the contrasting colours. Also characteristic of Steen is the care with which he painted the individual still-life elements, such as the solitary slipper and the wicker basket holding the chamber pot.

42

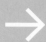

Jan Steen
'The Sick Girl', *c.* 1660/62
Panel, 58 × 46.5 cm

Diagonal Perspective
The diagonal perspective used by Jan Steen in this painting is exceptional, since his rooms usually look like imaginary peepshows, with the rear wall running parallel to the picture plane. Here, however, we look obliquely through the room to the corner where the walls meet. This means that there is not one central vanishing point but two, to the left and right on an imaginary horizon line in or outside the picture. Diagonal perspective was first introduced around 1650 by Gerard Houckgeest, a Delft painter of church interiors. It is quite difficult to create a convincing illusion of space using this system. The floor in the foreground, for example, has the tendency to slope. To conceal this, Steen later added the lap dog on its pillow.

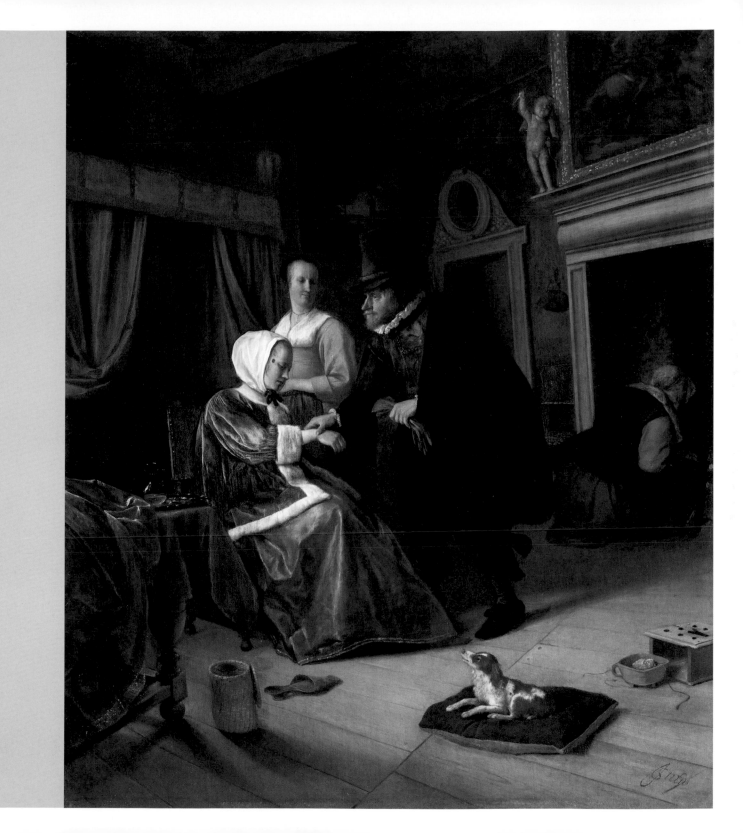

Changes

Infrared imaging has revealed several striking facts. The lap dog, for instance, was not included in the preliminary design. Next to the foot-stove and pan of coals, Steen initially painted an open bed warmer, which he later painted out and replaced with the dog. A bed warmer would have been quite appropriate in this context, because when filled with glowing coals, it served to warm the bed in which the lovesick girl would quickly be tucked up. No space on the mantelpiece was reserved for Cupid with his bow and arrow; the statuette appears to have been added later on in the painting process, probably to underscore the meaning of the picture. Finally, the shape of the brocade-edged tablecloth was changed in the final paint layer, and made to hang lower.

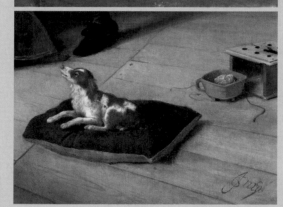

Above: infrared image of 'The Sick Girl' (detail)

Lap Dog

In this painting from the Wellington Museum in London, the joke is laid on thickly, if only through the caricature of a doctor with his self-important look. The lovesick woman has assumed the classic pose of melancholy, resting her head on her hand. She is so far gone that she ignores everything and everyone, so that the doctor feeling her pulse is forced to address the maid, standing at the ready with the flask of urine. The purse and keys of the listless patient hang on the chair in front of her, for she is obviously incapable of carrying out her household duties. Here, funnily enough, Cupid has become a boy of flesh and blood. He sits at the lower left, ready to fire one of his arrows at us — the viewers of this spectacle — who have thus been assigned a role in this farce.

Hanging on the rear wall is a painting of Venus and Adonis, a well-known love story from classical mythology (the unfortunate death of Adonis leaves Venus lonely and forlorn). Also recognisable is Frans Hals's 'Peeckelhaering', the fool who comments on human folly. The old man in the back room has sometimes been taken to be the woman's impotent old husband, though he is more likely to be her father, who must be worked on by every conceivable means to consent to the marriage his daughter so fervently desires. The lap dog lying on its pillow at the sick woman's feet is almost exactly the same as the dog that appears in the Mauritshuis painting, although here it tellingly wears a collar with a heart around its neck.

Jan Steen
The Doctor's Visit, c. 1661/62
Panel, 49 × 42 cm
Wellington Museum, Apsley House, London

Well-Known Motto

In the seventeenth century it was commonly thought that the only cure for lovesickness was a healthy dose of the person who had caused it in the first place. Not only was this remedy seriously recommended by many contemporary medical publications, but it was also propagated by plays and literature.

A good illustration of this is the well-known emblem by Otto van Veen, from his *Amorum Emblemata* of 1608. A cupid examining a flash of urine feels the pulse of a bedridden cupid with an arrow in his heart. The motto reads: *Amans Amanti Medicus,* the beloved is the doctor of the beloved.

Otto van Veen
Amans Amanti Medicus from *Amorum Emblemata,* 1608
pp. 168–169. University Library, Leiden

Drunken 'Doctor'

Sunk deep in the pillows, with one arm flung limply above her head, a sick girl lies in her sumptuous bed, with the 'doctor' at her side. The diagnosis will no doubt be 'love fever'. On the right, two little dogs sniff each other's backsides at the top of the stairs leading to the rear room. They allude to the only effective remedy for the patient's condition: intercourse with her beloved. The painting-within-the-painting, which depicts the rape of the Athenian maidens by the Centaurs, can also be interpreted as an allusion to the (longed-for) loss of virginity.

The doctor in old-fashioned garb is not a real physician, but — as always in the work of Steen — a charlatan, an object of ridicule. His attention has been momentarily distracted by a young woman who hands him a glass of wine. Her elegant attire beneath her apron shows that she is merely playing the part of maidservant. With his hat perched crookedly on his head, the sham doctor looks tipsy already. The chamber pot on the chair and the flask of urine on the table indicate what he must do: examine the patient's urine in order to make a diagnosis. Uroscopy, traditionally a serious diagnostic method, was increasingly disparaged in the seventeenth century. Thus the chamber pot became the invariable attribute of quacks in both the visual and dramatic arts.

Many of the details in this picture were meticulously worked out with true feeling for the texture and appearance of the various materials: the fine Persian carpet on the table, the brass chamber pot, the gilt lobate frame around the painting, the gold-leather wall-covering in the adjacent room, the satin clothing of the 'maid' and the Delftware jug in her hand, with imitation Chinese decoration. The quacks in Steen's early paintings are toothpullers and stone-cutters who take poor peasants for a ride, whereas his 'doctors' from the 1660s clearly operate in better circles.

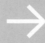

Jan Steen
The Doctor's Visit, *c.* 1660/62
Panel, 60.5 × 48.5 cm

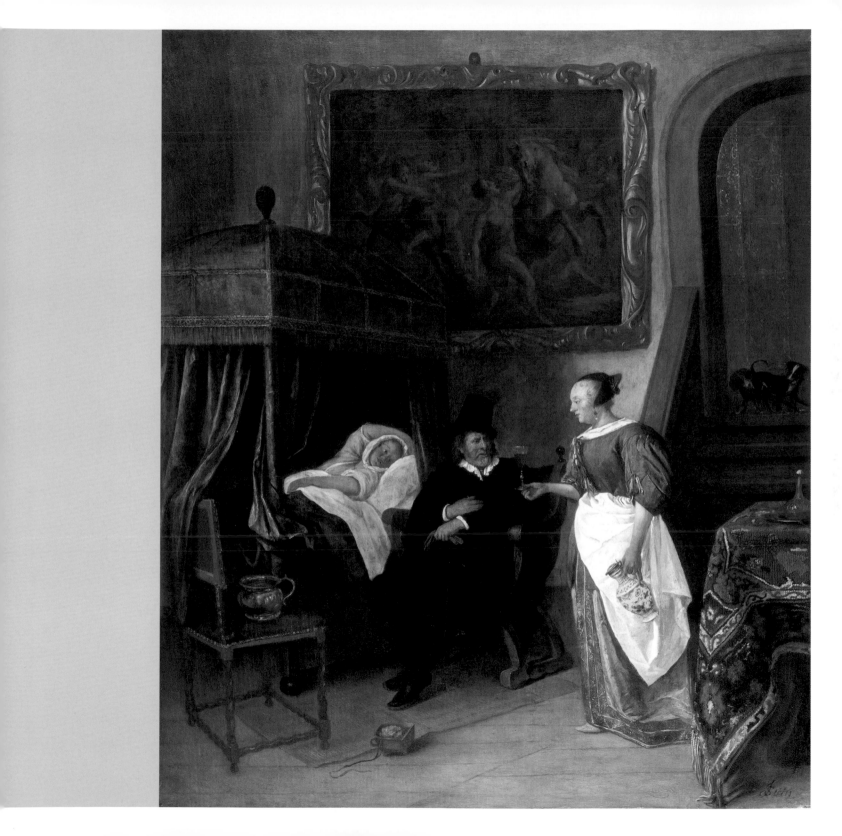

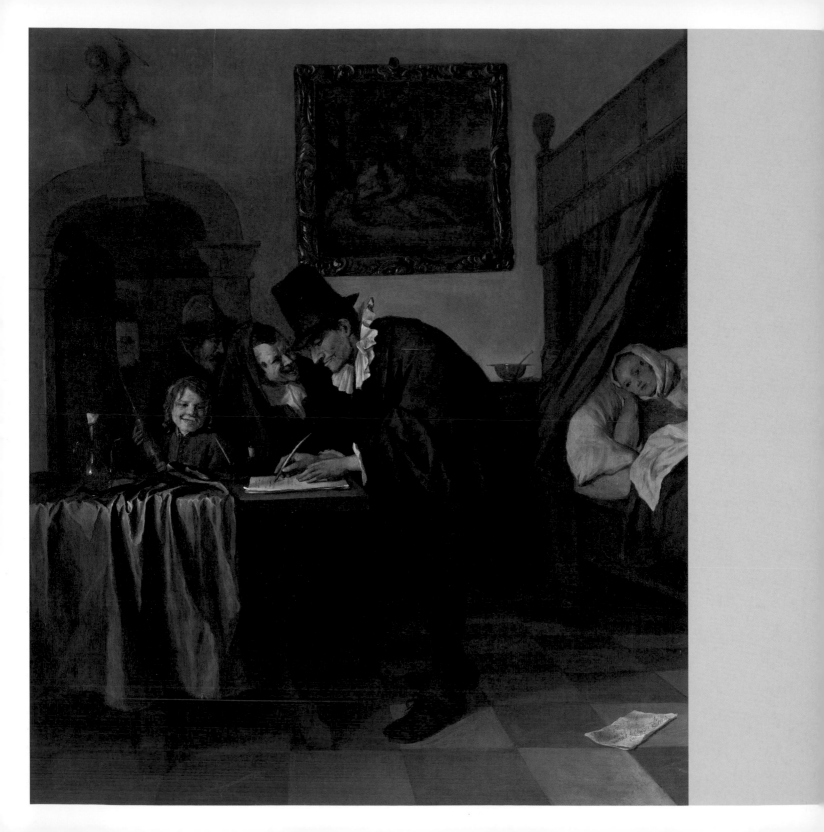

Beauty Spots

Each of these three sick women by Steen has a mouche, or beauty spot — actually a round piece of cloth — stuck on her temple. These patches served to emphasise the skin's whiteness. That an ugly old procuress would also sport a beauty spot is, of course, intentionally absurd.

Details of *The Doctor's Visit* (p. 47), *'The Sick Girl'* (p. 43) and *'Medicines are all in vain, in treating this girl's lovesick pain'* (p. 48)

Lovesickness

Here a doctor writes a prescription for the lovesick girl lying listlessly in bed — to no avail, that much is clear. 'Medicines are all in vain, in treating this girl's lovesick pain' ('Hier baet geen medesyn, want het is minnepyn') is written on the piece of paper lying on the floor, behind the doctor's feet. The painting-within-the-painting of a mythological or pastoral pair of lovers, as well as the statuette of Amor above the door, are allusions to the only effective remedy. The old woman whispering in the doctor's ear is probably a procuress, offering her services with a smirk. Even more suggestive is the dirty laugh of the boy sitting at the table, who holds an enema in his hand, an overt allusion to sexual intercourse. This boy is too young for actual love-making, and the man behind him probably too old. He may well be the father, who must see to it that his daughter marries the man she loves as quickly as possible.

Jan Steen

'Medicines are all in vain, in treating this girl's lovesick pain', c. 1662
Panel, 61 × 49.5 cm
Museum Boijmans Van Beuningen, Rotterdam (on loan from the Willem van der Vorm Foundation)

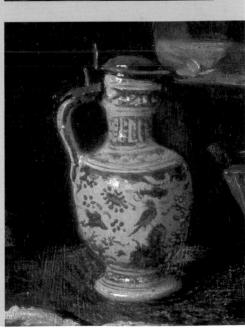

Attributes

Steen often painted the same attributes in his works. The Delftware jug from *The Doctor's Visit* also appears on the table in *'The Oyster Eater'*.

Details of *The Doctor's Visit* (p. 47) and *'The Oyster Eater'* (p. 33)

'As the Old Sing, So Twitter the Young'

The Mauritshuis not only has the smallest painting by Jan Steen (*The Oyster Eater*) in its collection, but also one of his largest works. This powerfully executed and colourful work is exceptionally big for a genre painting. Its title derives from the inscription on the sheet of music held by the grandmother at the table, whose index finger follows the words of the song she sings: 'Soo voer gesongen soo/na gepepen', a variation on the ever-popular proverb 'As the old sing, so twitter the young', which Steen — following the Flemish artist Jacob Jordaens — portrayed repeatedly.

Depicted here are three generations of a family who celebrate in lively and disorderly fashion the baptism of the youngest offspring, the child on the mother's lap, who is at the very heart of the composition. The laughing old man on the left jauntily sports a 'new father's cap', the head-covering traditionally worn by the father when his child is baptised. Such an old man should not become a father, however, and further proof of the upside-down world portrayed here is the behaviour of the adults. The smoking and drinking they indulge in sets a bad example for the children, who faithfully follow suit. The broadly grinning man on the right — Jan Steen himself — mocks his fatherly duties by teaching his son to smoke, thus portraying the 'copycat piping' ('na-pijpen') of the youngest generation. 'Piping' is also portrayed by the older boy, who blows on his bagpipes, an instrument with all sorts of negative connotations, such as laziness and licentiousness. The woman with her blouse half open, leaning back in her chair on the left, also gives a vulgar impression, stretching her arm out so that a servant can pour more wine in her glass. Behind her, sitting on its perch, is a parrot — another notorious imitator.

Jan Steen
'As the Old Sing, So Twitter the Young',
c. 1668/70
Canvas, 134 × 163 cm

Grand Gesture

'As the Old Sing, So Twitter the Young' is a monumental and self-assured painting, executed with unerring brushwork. Its exceptionally large size suggests that it was made not for the free market, but to commission. The broad brushwork, moreover, indicates that it was intended to be viewed from a distance.

Compared with the earlier variant in Montpellier (p. 55), the composition has been enlarged, zoomed in on, and reduced to essentials, with the motif of wine-pouring greatly magnified and emphasised. The jug stands out beautifully from the light-coloured wall, as do the stream of red wine and the half-full wineglass. This grand gesture forges a unifying link, connecting the woman at the front left via the wine-pourer to the group on the right, behind the table.

The fluent manner of painting is sometimes attributed to the influence Frans Hals supposedly exerted on Jan Steen during his stay in Haarlem.

Laughing Steen

Although this painting was long taken to be a portrait of the painter and his family, this interpretation goes too far. Steen was merely making use of familiar models from his own circle of acquaintances, including himself and possibly his wife, Grietje, on the left (both, by the way, at a young age). It becomes much more difficult — if not impossible — to recognise Steen's own offspring among the children. That Steen cast himself in the role of the father who laughingly sets a bad example testifies to the self-mockery that gives this picture its punch.

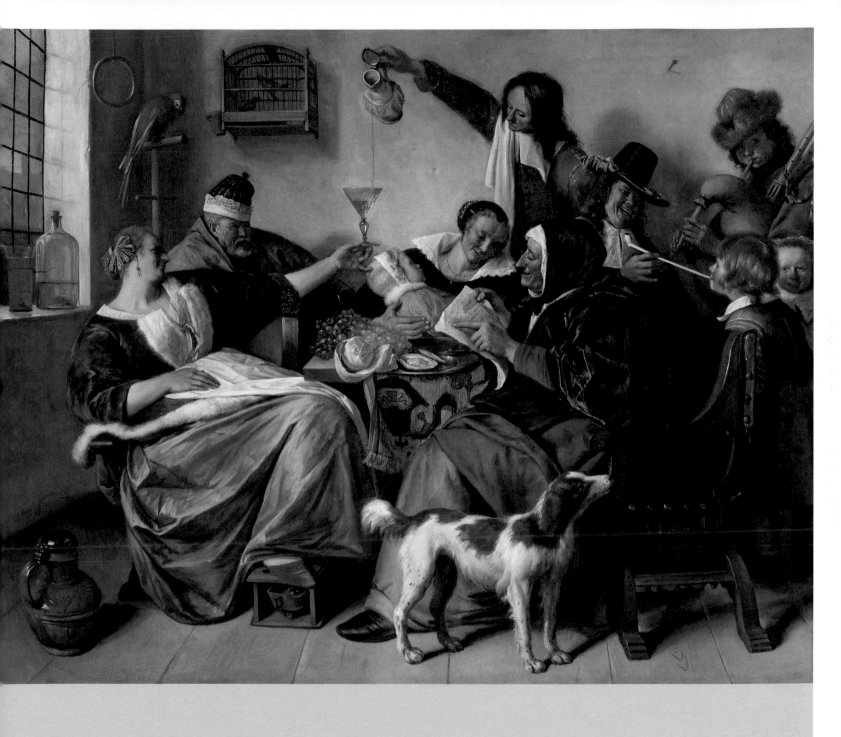

Dog Aids in Dating

Jan Steen rarely dated his paintings, so it is difficult to establish the chronology of his oeuvre. After all, the development of an artist never runs in a straight line. Work from any given period may display a variety of styles and techniques, depending on the artist's intentions.

Sometimes there are concrete leads for a possible dating; in 'As the Old Sing, So Twitter the Young', one such clue is the dog. Steen added this animal at a late stage, as a kind of afterthought, presumably to fill the rather empty foreground and thus strengthen the sense of depth. The same dog (in the same pose) occurs in *Twelfth Night* of 1668 (p. 53), where it looks up attentively at the

rommelpot player doing an egg dance, thus playing a real role in the depiction. By contrast, the dog in 'As the Old Sing' stares into emptiness. Steen often borrowed motifs from his own work, with the result that a recycled motif sometimes appeared out of context. It therefore seems reasonable to consider the Mauritshuis painting of later vintage than *Twelfth Night*, and to date it to the years 1668–1670, his late period in Haarlem. The infrared image of the painting reveals, incidentally, that Steen altered the dog's original contours.

Left: infrared image 'As the Old Sing, So Twitter the Young' (detail)

Feast of the Epiphany

Jan Steen painted many versions of the feast of the Epiphany, or Twelfth Night, a subject that provides an opportunity to present a colourful array of characters. Here the toddler, wearing a paper crown, plays king for a day, standing on a stool next to the epiphany candles. Only when he has taken his first sip can the festivities begin, as the assembled revellers proclaim 'The king drinks!' Steen's motley company, however, has long since begun their celebrations. The woman in the middle, holding the wine jug and a dangerously wobbling wineglass, seems sloshed already. This is indeed a topsy-turvy world, in which the roles are reversed, and Steen stresses this by casting a toddler in the role of king and teaching him to drink at such a young age. In this respect the scene fits in with Steen's portrayals of the proverb 'As the old sing, so twitter the young'. Jacob Jordaens sometimes painted the two subjects as pendants, and it is possible that Steen did as well. In 1712 two of his paintings, which presumably belonged together, were put up for sale at an Amsterdam auction: one bore the title *As the Old Sing* and the other *Twelfth Night*. We are not certain that these works have survived.

Jan Steen
Twelfth Night, 1668
Canvas, 82 × 107.5 cm.
Staatliche Museen, Gemäldegalerie
Alte Meister, Kassel

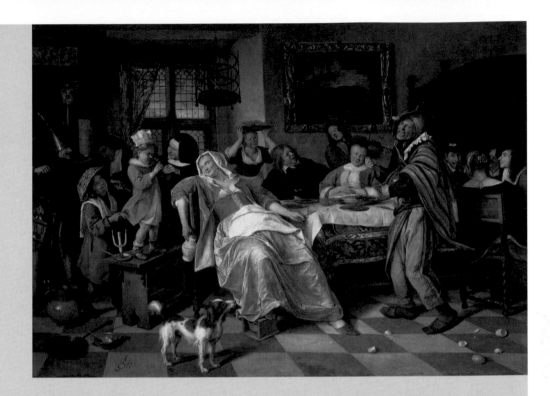

Source of Inspiration

Jacob Jordaens was the first to paint the proverb 'As the old sing, so twitter the young'. His earliest painting of this subject dates from 1638 and was also published as a print, with the result that the composition became widely known. Jan Steen carefully studied the work of his Flemish predecessor and borrowed various motifs from him. In Jordaens's painting we also see three generations ranged around a laid table, a mother with a child on her lap, a grandmother with a pince-nez, who sings from a sheet of music, and youngsters playing the recorder and bagpipes. Jordaens's companies, however, are rather refined, whereas the adults portrayed by Steen shamelessly indulge in their bad habits in front of the younger generation.

Jacob Jordaens
As the Old Sing, So Twitter the Young, 1638
Canvas, 154 × 208 cm
Musée des Beaux-Arts, Valenciennes

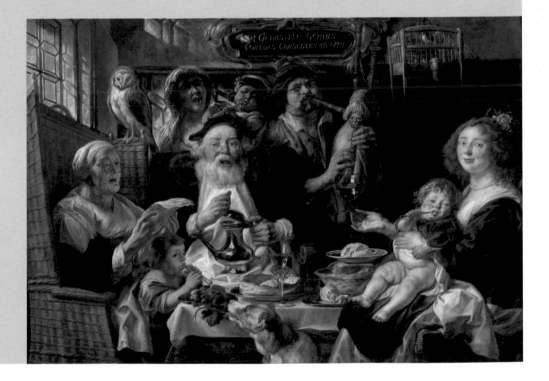

An Earlier Version

The museum at Montpellier has an early variant of *'As the Old Sing, So Twitter the Young'*, in which most of the figures appear in the same arrangement: the woman holding a wineglass, the old man behind her (this time without the 'new father's cap'), the wine-pourer, the mother and child, and the singing grandmother. Apart from the obvious similarities, there are also important differences with the Mauritshuis painting, which is anything but a slavish copy. The canvas in Montpellier is smaller, the figures are depicted on a smaller scale, the interior is much more complicated, and there is far more accessory detail, including a curtain pushed to the side which suggests that 'all the world's a stage'.

Jan Steen was well aware of how to create the illusion of space, but he was not bothered about following the rules of perspective too closely; attempts at verification have shown that neither painting can be said to have a vanishing point. In the Mauritshuis painting, the space depicted is highly simplified, but the sense of depth is more convincing in some respects than in the work in Montpellier. The woman holding the wineglass and the singing grandmother, for example, sit closer together, so that the awkwardly floating table leg is hidden from view.

Jan Steen
'As the Old Song, So Twitter the Young',
*c.*1662. Canvas, 94.5 × 81 cm
Musée Fabre, Montpellier

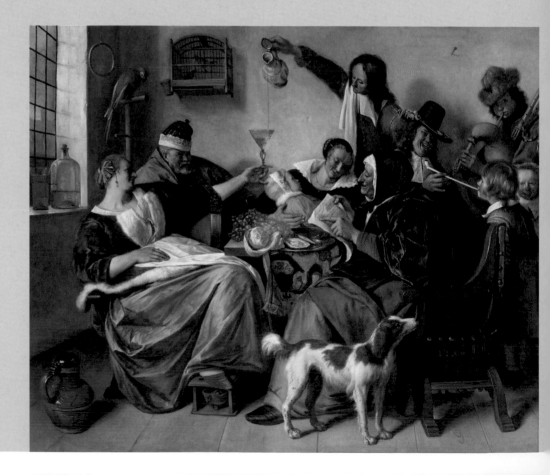

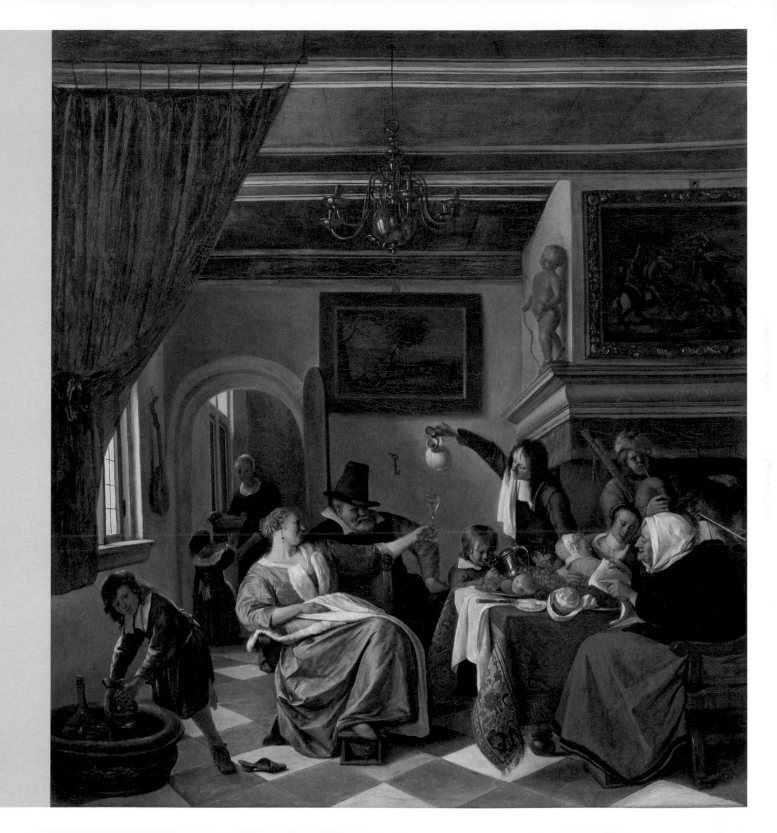

'A first-rate and especially beautiful piece'

On a piece of paper pinned to the mantelpiece we read the proverb portrayed here: 'As the old sing, so twitter the young' ('Soo de oude/ Songe/ Soo pypen de/ Jongen'). This is typical of the explanatory inscriptions with which Jan Steen often provided his pictures. But those familiar with his work do not need such clarification, since every well-known allusion to 'piping' ('pypen') is depicted here. In the middle, Jan himself sets a bad example by grinning broadly as he draws on his long Gouda pipe, while a woman seated next to him at the table, fills a pipe of her own. Behind them, a boy plays the bagpipes and on the right another boy plays the recorder — musical improvisations on 'piping' which Steen borrowed from Jordaens. Here it is the grandfather who sings from a book of music, while the grandmother holding a toddler (wearing a protective cap and holding a rattle) tries to teach the child how to dance — altogether an endearing sight that would not offend anyone. This is not necessarily true of the young, wine-drinking couple standing near the bed in the background. Their behaviour may well suggest that intemperate drinking can lead to illicit sex, though Steen has merely hinted at this possibility.

A striking element is the large birdcage hanging from the ceiling (in the other *'As the Old Sing, So Twitter the Young'*, a birdcage hangs on the wall). In one of Jordaens's portrayals of the proverb, a fool holds up a birdcage — with little birds twittering along — to which he points, grinning broadly. The Dutch proverb 'Every bird sings its own song' was well known in the seventeenth century; it means that behaviour is a question of man's innate nature.

'A first-rate and especially beautiful piece... being painted in a clever and masterly way' were the words used by Pieter Terwesten in 1770 to describe this painting in his catalogue of the collection of Stadholder William V, who owned no fewer than six paintings by Jan Steen. The canvas was generally praised as one of the master's best works. Steen's signature appears, as though cast in brass, on the mortar in the right foreground.

Jan Steen
As the Old Sing, So Twitter the Young,
c. 1663/65
Canvas, 84 × 92.6 cm

Unfortunately the paint surface has been damaged. This is said to have occurred during a relining of the canvas that took place before 1864, because in that year the painting was again relined, and later yet again. In 1864 David Bles, a painter well known at the time, supposedly 'touched up' several of the faces. Now it is mainly the faces of the old man and woman on the left that are heavily overpainted. Even so, the high quality of the original painting is still visible in many places: these passages include the toddler, whose small hand nearly touches the wrinkled hand of the grandmother, the woman filling her pipe, the brilliantly executed birdcage and the boy playing the recorder. The button missing from his jacket is typical of the everyday details to which Jan Steen paid particular attention.

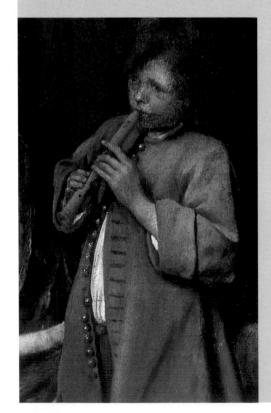

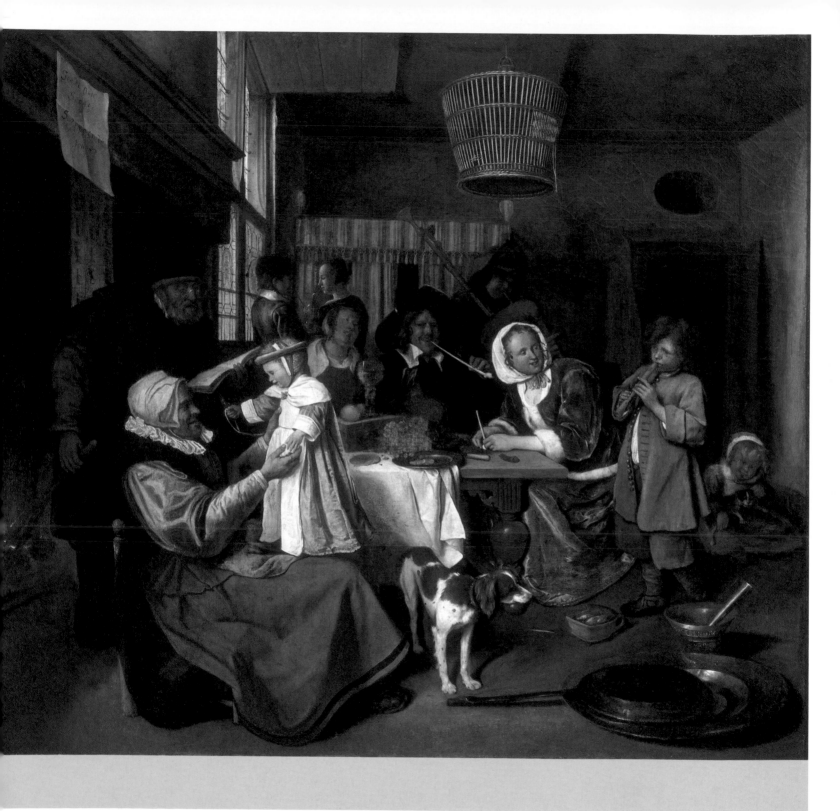

All the World's a Stage

From behind a raised cloth — a kind of stage curtain — we are afforded a glimpse of the busy bar of an inn, where young and old alike seek diversion. People engage in eating and sometimes heavy drinking, and amuse themselves making music and playing tric-trac. A young woman turns away from a much older man who offers her an oyster; her laugh suggests that she may yet accept his advances. Behind them, a hunchback with an out-of-tune fiddle ridicules this ill-matched couple. The woman at the table on the right appears to be having more success; her sultry gaze is directed at the man playing the lute next to her, to whom she offers an oyster. This aphrodisiacal delicacy is being prepared in great quantities by the personnel: on the left, a man opens the oysters while a serving girl, kneeling on the floor, pours lemon juice over them. A boy encourages a cat to dance on its hind legs, while he beats time with a spoon; a girl carries a dog in her apron; and a crowing toddler sitting on an old man's lap tries to grab the parrot from its perch. In the right foreground, a boy carrying a basket of bread rolls under his arm watches the proceedings. Similar children, seen from the back, occur more often in the work of Jan Steen: they serve to draw the viewer's eye into the picture.

The raised curtain makes it clear that this is not just any inn, but one that represents 'the world stage'. The comparison of the terrestrial world to a theatrical performance stems from antiquity. Around 1600 Shakespeare immortalised the image in *As You Like It*, in an extended metaphor that starts with the line: 'All the world's a stage'. In seventeenth-century Holland the metaphor was also well known, as evidenced by a couplet written by the poet and playwright Joost van den Vondel to grace the entrance to the Amsterdam theatre: 'The whole world is a stage; each man plays his role and gets his share'. Steen underscored the fleeting nature of life by means of a detail that is not immediately apparent: a boy, lying in the loft above, blows bubbles onto the guests below; beside him is a skull. 'Homo bulla' ('Man is a soap bubble') — a well-known and unambiguous motif — is often personified by children blowing bubbles. The message is clear: beware, because before you know it, your life might burst like a bubble. The gallows in the painting on the rear wall seem to underline this theme. When this painting appeared in a 1733 sale catalogue, it was already called *The Life of Man*.

Jan Steen
The Life of Man, c. 1665
Canvas, 68.2 × 82 cm

Active in Haarlem
Between 1660 and 1670, Steen was again living in Haarlem, the city where he had once been a pupil of Adriaen van Ostade. The influence of Van Ostade's early work is unmistakable in Steen's earliest peasant scenes. In the 1660s his former teacher was still active in Haarlem, and Steen seems to have studied his later, more polished work as well. In *The Life of Man* we can detect the influence of Van Ostade's inn interiors from the 1650s and 1660s — large rooms with small, keenly observed figures — which is why this painting is generally dated to about 1665. Nine out of ten paintings by Steen are undated, however, so any estimate of this kind is merely a rough guess.

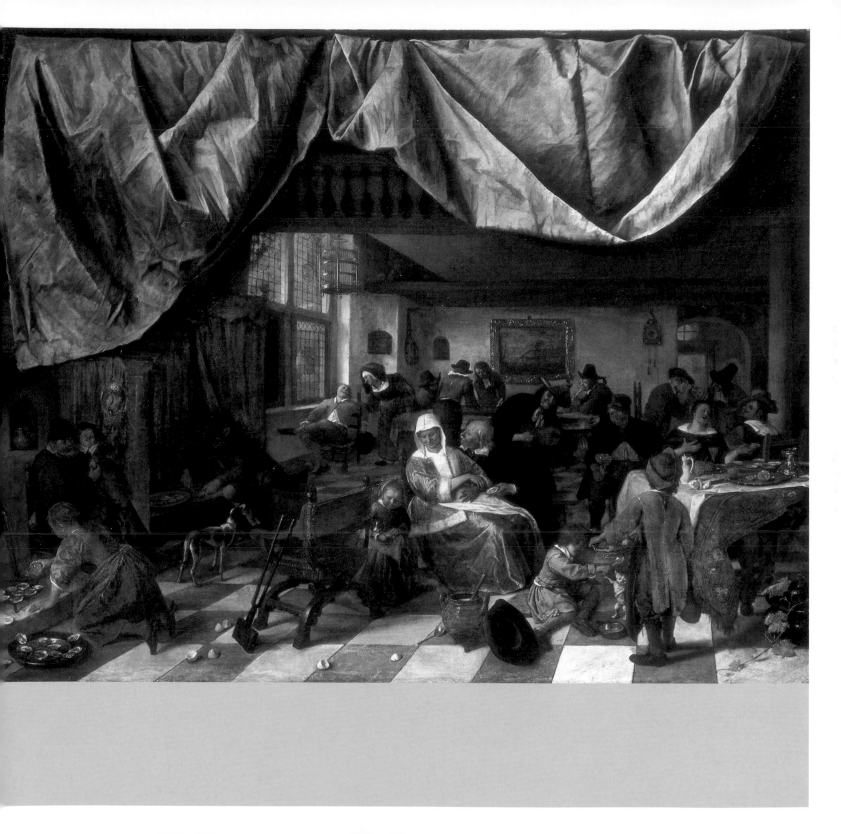

Hunchback Overpainted

The hunchback tuning his fiddle was overpainted at some point in the past. This must have happened before 1829, when a line engraving of the composition — without the hunchback — appeared in the collection catalogue of the Mauritshuis. The hunchback is likewise missing from a coloured drawing made by Reinier Craeyvanger (1812–1880) after this painting. It is not known why he had to disappear, but he made his comeback during a restoration carried out in 1957.

Wrinkled Satin

The curtain is an important motif in this painting, whose source of inspiration is likely to have been in Leiden rather than Haarlem. The Leiden art collector Hendrick Bugge van Ring owned this unusual collaborative painting of 1658: a trompe-l'oeil of a garland of flowers, executed by Adriaen van der Spelt, and a blue satin curtain pushed to the side, painted by Frans van Mieris. The folds in the fabric and the way it catches the light convincingly suggest the wrinkles in the gleaming material. In *The Life of Man*, Steen's raised satin curtain — originally a much brighter blue — is so similar to this curtain by Van Mieris that it

almost seems like a response to it. Bugge van Ring was an important customer of Steen; in 1667 he owned six paintings by the master. He was also the owner of Frans Hals's *'Peeckelhaering'*, a work that Steen depicted a number of times as a painting-within-a-painting in his own compositions (see p. 44). Steen must have known Bugge van Ring and his collection very well indeed.

Adriaen van der Spelt and Frans van Mieris
Trompe-l'Oeil Still Life with a Flower Garland and a Curtain, 1658
Panel, 46.5 × 63.9 cm. The Art Institute of Chicago

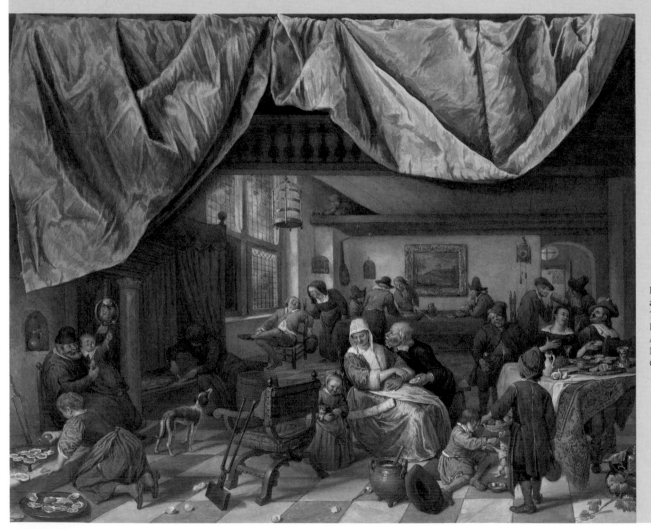

Reinier Craeyvanger after Jan Steen
The Life of Man
Drawing, 33.6 × 40.5 cm
Amsterdams Historisch Museum, Bequest of C.J. Fodor

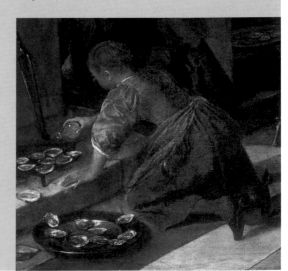

Details

The Life of Man is bursting with details that refer to proverbs and pieces of popular wisdom. For example, the broken eggshells on the floor may well symbolise the frailty of life. In the background, at right, the old woman gazing deep into her tankard is a *kannekijker* (literally someone who 'looks into the jug'), meaning a guzzler. The porridge pot, too — whether or not with a spoon — occurs in various sayings, as does the hat lying next to it on the floor. Steen succeeded admirably in suggesting the gleam of the earthenware pot and the dull felt of the hat.

Discoloured Blue

The various blue passages in this painting have suffered a great deal and are very discoloured. In some places the blue has faded, destroying the effect of the shadows and the clarity of the modelling, as evidenced by the serving girl's jacket. In other places, such as the curtain, the blue has taken on a greyish hue. Oil paints containing the blue pigments ultramarine and smalt are particularly vulnerable.

Hendrick Goltzius
Homo bulla, 1594
Engraving, 21.2 × 15.3 cm
British Museum, London

'Quis evadet?' ('Who will escape?') is the motto inscribed on this 1594 print by Hendrick Goltzius. No one will escape, that much is clear.

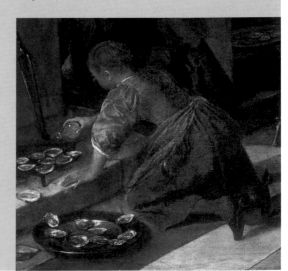

A Drink for an Ageing Woman

It is not always easy to understand Jan Steen's paintings, partly because they portray so many puns and sayings that have fallen out of use. This picture of a man and woman preparing a drink of some kind in a simple interior is one such enigmatic painting. What is the meaning of this scene? It was first given its present name — 'The Caudle Makers' — at an exhibition held in 1881, but this title cannot be correct. The main ingredients of caudle — a drink traditionally served at maternity visits — are eggs and cinnamon sticks, which are not depicted here. This man is grating something, however, most likely nutmeg intended for the drink this woman is stirring. The vessel she holds is a silver brandy bowl, recognisable by its characteristic horizontal handles. Remarkably, the man wears the kind of old-fashioned clothing in which Steen generally dresses his sham doctors, so it stands to reason that this picture represents quackery and old age. Is he preparing a drink to warm the woman's old bones? The fire burning in the hearth behind her might also allude to this theme.

Steen used fluent and unerring brushstrokes to apply the paint in thin layers. The palette consists mainly of shades of brown, enlivened with a few accents in red and white. The figures' facial types betray, once again, the influence of Adriaen van Ostade. Here we see a rather frequent feature of Steen's work: the perspective, which he attempted to define by means of two nails hammered into the wall, remains shaky. The dating of this work to the second half of the 1660s is supported by dendrochronological examination of the wooden support.

Jan Steen
'The Caudle Makers', c. 1665/70
Panel, 41 × 31.5 cm

First Record
This painting was first recorded in 1813, when it was sold at auction from the collection of the extremely wealthy Amsterdam Mennonite Jan Jacob Brants (1741–1813), who owned three paintings by Steen. The description in the sale catalogue reads: 'An interior, in which a woman, sitting at a table, prepares a drink in a brandy bowl; a man standing in front of her grates nutmeg; on the table: a bottle, towel and other utensils. Cleverly composed and beautifully painted.'

Dendrochronology
Seven of the Jan Steens in the Mauritshuis were painted on wooden supports. Dr Peter Klein of the University of Hamburg carried out dendrochronological research on all seven panels. Knowing when the tree or trees from which a panel is made were felled can aid in dating a painting. This work could not have been made before 1658, but an origin after 1668 is more likely. The dendrochronological research carried out on the other six panels did not yield any new insights that have a bearing on their time of origin.

A Pig Belongs in the Sty

From the 1650s onwards, Jan Steen situated most of his comic scenes in higher social circles, but in a few of his late paintings he reverted to the peasant milieu of his earliest compositions. The rustics in this painting surrender more than ever before to unbridled debauchery. 'A pig belongs in the sty' is the proverb portrayed here, in imitation of Pieter Bruegel the Elder. The centre of attention is a drunken woman wearing torn clothes that reveal her naked breasts. Supported by other drunkards, all laughing themselves silly, she stumbles down the steps towards a pig sty at the lower right, following a man playing the fiddle and encouraged by a crowd of people whooping with glee, while children point and poke fun at her. A boy stands at the ready with an earthenware pot, perhaps containing water to throw on her, to sober her up. In the left background a stray pig laps up the vomit of an unconscious boozer, and behind the fiddler someone has collapsed in paralytic drunkenness against the tree. In many proverbs and expressions the pig is seen in a very unfavourable light, as an unrivalled example of drunken and licentious behaviour — though these inebriated peasants are clearly no better. Steen situated his satirical scene outside an inn, beneath a makeshift pergola propped up by a tree. From the window on the right three figures, reciting in the manner of rhetoricians, deliver their commentary on this scene of wanton excess.

Steen carefully executed certain parts of the composition, such as the boy holding the earthenware pot, whose eyes are hidden beneath the brim of his hat, the laughing fiddler, whose hands are depicted in minute detail, and the pig, peeking curiously out of its sty. Other passages, by contrast, were rapidly executed in fairly rough brushstrokes. The figures in the background are depicted in a cursory manner, which makes them seem more distant. In his customary way, Steen introduced small changes to the composition during the painting process. The beer barrel, for example, is a later addition, as is the pewter jug dangling from the hand of the drunken protagonist. 'A very charming Steen' were the words used by Abraham Bredius, director of the museum, to describe this painting, which he bequeathed to the Mauritshuis — along with two early works by the master — in 1946.

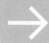

Jan Steen
A Pig Belongs in the Sty
c. 1674/78
Canvas, 86 × 72 cm

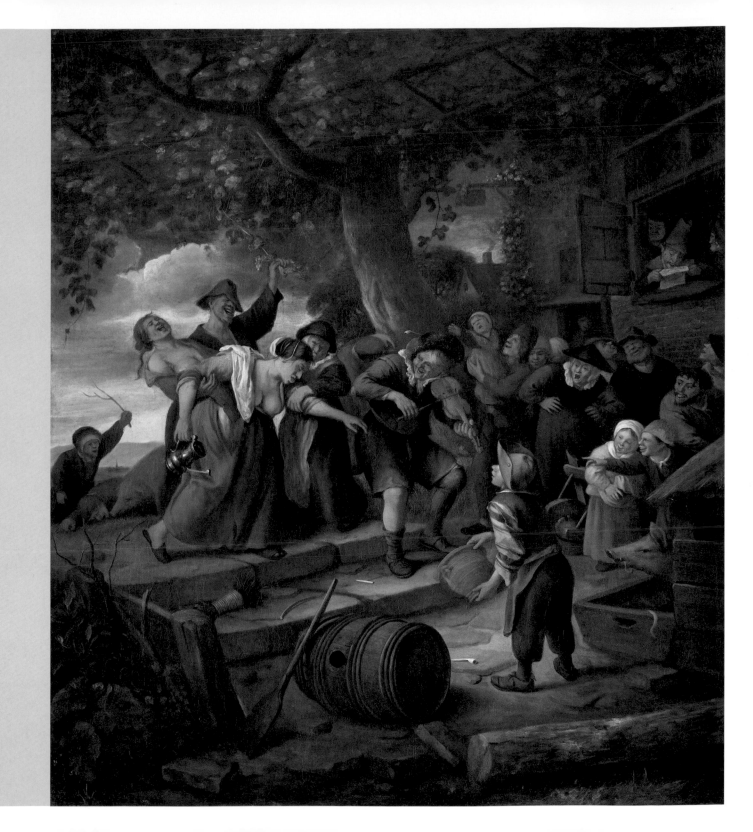

Overpainted Dog

The infrared image reveals that the place of the beer barrel was first taken by a dog, crouching down on its front paws and raising its head in the air to bark at the intoxicated peasant woman. It resembles the excited dog in *'Wine is a Mocker'* (the two animals' hindquarters, in particular, are similar). The beer barrel was perhaps introduced to mark more clearly the path to the pig sty. Changes were also made to the boy holding the pot. His feet were originally placed lower, which made him quite a bit taller. Various changes are also visible in his cap, clothing and the pot he holds. With a microscope it is possible to see, through minuscule holes in the paint surface, a layer of red paint below the boy's striped sleeve.

Left: infrared image of *A Pig Belongs in the Sty* (detail)

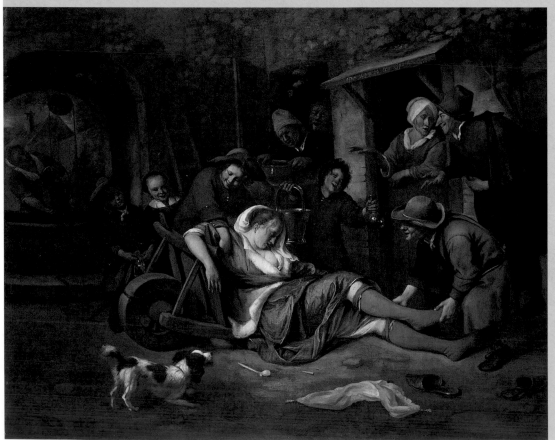

'Wine is a Mocker'

A woman lies in a drunken stupor in front of an inn. Bystanders hawl buckets of water to throw over her and bring her to her senses, while laughing children try to hoist her onto a wheelbarrow, and a dog barks its commentary on the scene. The woman's beautiful jacket is half open, she has lost her slippers, and her lovely skirt of *changeant* satin is hiked up to expose her bare legs above her stockings. The quality of her clothing, however, indicates that this is not a peasant but a middle-class woman who has disgraced herself.

The appropriate biblical passage is written on the edge of the small roof above the inn door: 'Wine is a mocker Proverbs 20.1'. The text reads in full: 'Wine is a mocker, strong drink is raging: And whosoever is deceived thereby is not wise.'

Jan Steen
'Wine is a Mocker', c. 1668/70
Canvas, 87.3 × 104.8 cm
Norton Simon Art Foundation,
Pasadena

Rhetoricians

Steen made at least six paintings that portray
rhetoricians reciting poetry in an open window,
with the blazon of their 'chamber of rhetoric'
hanging from the windowsill. These pictures
invariably include three figures: the *declamator*,
who reads aloud from the text (here he wears a
laurel wreath); the *factor*, who wrote the poem
(probably the man with upraised finger); and the
momus, the critic (here literally shedding light on
the text). The figures in the window of *A Pig Belongs
in the Sty*, declaiming their commentary on what
is happening below, resemble the rhetoricians
in these pictures. The only thing missing is the
blazon.

 Every city in the Netherlands had a
'chamber of rhetoric' (*rederijkerskamer*): a literary
and dramatic society whose members met to
recite poetry, perform plays, and stage *tableaux
vivants*. Rhetoricians performed at fairs and yearly
markets and on other festive occasions. Chambers
of rhetoric arose in the fifteenth century, and
experienced their heyday in the sixteenth. During
the seventeenth century their moralising lessons
became old-fashioned and they gradually played
out their role, owing in part to the rise of profes-
sional theatre troupes. Steen was fond of mocking
rhetoricians, who were known for their love of
drink. The earthenware jug on the windowsill
in *The Rhetoricians* undoubtedly refers to their
notorious drinking habits.

Jan Steen
The Rhetoricians, *c*.1665
Panel, 40.5 × 34 cm
Private collection

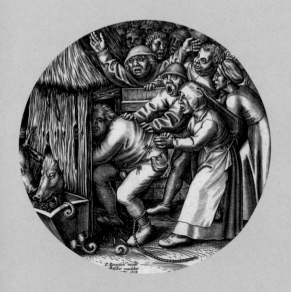

Bruegel's Example
Pieter Bruegel the Elder must have been the first to portray
the proverb 'A pig belongs in the sty'. Various prints and painted
copies were made after his design of 1557. Steen's pig — with its
head above the trough and a potato peel hanging from its snout
— seems to have come straight out of a print by Bruegel.

Jan Wierix after Pieter Bruegel the Elder
A Pig Belongs in the Sty, 1568
Engraving, diam. 18.1 cm
British Museum, London

1

Peasants Dancing at an Inn,
c. 1646/48
Panel, 38.5 × 56.5 cm
Signed lower left:
JSteen

PROVENANCE
Maria Beukelaar, The Hague, 1742;
Nicolaas van Bremen, The Hague,
1769; J.A.A. de Lelie, Amsterdam, 1845;
W. Gruyter, Amsterdam, 1882; Herman
Wirz, Cologne; Abraham Bredius,
The Hague, 1890–1946 (on loan to
the Mauritshuis since 1890); Royal
Picture Gallery Mauritshuis (bequest of
Abraham Bredius), 1946 (inv. no. 553)

2

Village Fair, c. 1650/51
Panel, 47.2 × 66 cm
Signed lower centre:
JSteen (JS interlaced)

PROVENANCE
Hennin collection, Paris, 1764;
A. Visscher-Boelger, Basel; art dealer
Job Schall, Baden-Baden; art dealer
J.E. Goedhart, 1901; Abraham Bredius,
The Hague, 1901–1946 (on loan to the
Mauritshuis since 1901); Royal Picture
Gallery Mauritshuis (bequest of
Abraham Bredius), 1946 (inv. no. 664)

3

The Toothpuller, 1651
Canvas, 32.5 × 26.7 cm
Dated on the right of the document:
1651

PROVENANCE
B. Warnaar; Willem Lormier sale,
The Hague, 4 July 1763, lot 252 (ƒ 160
to T.P.C. Haag for William V); Prince
William V, 1763–1795; Musée
Napoléon, Musée du Louvre, Paris,
1795–1815; William V Gallery,
1815–1822; Royal Picture Gallery
Mauritshuis, 1822, Prince William V
Gallery, 2010 (inv. no. 165)

4

The Fortune Teller, c. 1650/54
Canvas, 73 × 59.3 cm
Signed lower right:
JSteen (JS interlaced)

PROVENANCE
M.J. Roelofs-Thijssen, Amsterdam, 1891; Baron Königswärter, Vienna; August
Janssen, Amsterdam; art dealer Jacques Goudstikker, Amsterdam, 1919;
P.W. Janssen, Amsterdam, 1926; M.J. IJzerloo, Rijswijk, 1941; art dealer P. de Boer,
Amsterdam, 1941; M.F. de Vries, Amsterdam, 1941; G.B. Lanz, Laren, 1941; art
dealer D. Katz, Dieren, 1941; Adolf Hitler, Führermuseum, Linz; Stichting
Nederlands Kunstbezit; Royal Picture Gallery Mauritshuis (on loan from the
Netherlands Institute for Cultural Heritage [ICN] since 1992), Prince William V
Gallery, 2010 (inv. no. 1111)

5

'The Oyster Eater', c. 1658/60
Panel (rounded at the top), 20.5 × 14.5 cm
Signed on the left above the door:
IS

PROVENANCE
Pieter Locquet, Amsterdam, sale
22 September 1783, lot 349 (ƒ 501 to Van
Winter); Pieter van Winter, Amsterdam;
his daughter Lucretia Johanna van
Winter, 1822, through her marriage to
Hendrik Six van Hillegom to the Six
collection, Amsterdam, sale 16 October
1928, lot 45 (ƒ 190,000 to Beets for
H.W.A. Deterding, London); Royal Picture
Gallery Mauritshuis (donated by Sir
Henri W.A. Deterding), 1936 (inv. no. 818)

6

Woman Playing a Cittern, c. 1662
Panel, 31 × 27.5 cm
Signed lower right:
JSteen (JS interlaced)

PROVENANCE
G. Smith sale, London, 10 April 1880,
lot 94 (£ 110); J.P. Heseltine, London;
Frits Lugt, Maartensdijk, 1919; E.G.
Verkade, Delft, H.J. Verkade-Van
Gelder, The Hague, 1928 (on loan to the
Mauritshuis since 1919); Royal Picture
Gallery Mauritshuis (purchased with
the support of private donors), 1928
(inv. no. 779)

7

Portrait of Jacoba Maria van Wassenaer, known as 'The Poultry Yard', 1660
Canvas, 106.6 × 80.8 cm
Signed and dated on wooden board at bottom left:
JSteen 1660 (JS interlaced)

PROVENANCE
Jan van Wassenaer, Lokhorst Castle, Warmond, 1660; by descent to his heirs,
probably until 1764; art dealer Philips van der Schleij, Amsterdam, 1769 (*f* 1000 to
William V); Prince William V, The Hague, 1769–1795; Musée Napoléon, Musée du
Louvre, Paris, 1795–1815; William V Gallery, 1815–1822; Royal Picture Gallery
Mauritshuis, 1822 (inv. no. 166)

8

'The Sick Girl', c. 1660/62
Panel, 58 × 46.5 cm
Signed lower right:
JSteen (JS interlaced)

PROVENANCE
Govert van Slingelandt, The Hague,
in or before 1752, sale 18 May 1768,
lot 34; Prince William V, The Hague,
1768–1795; Musée Napoléon, Musée
du Louvre, Paris, 1795–1815; Prince
William V Gallery, 1815–1822; Royal
Picture Gallery Mauritshuis, 1822
(inv. no. 167)

9

The Doctor's Visit, c. 1660/62
Panel, 60.5 × 48.5 cm
Signed lower right:
JSteen (JS interlaced)

PROVENANCE
Johan van Schuylenburch, The Hague,
sale 20 September 1735, lot 71
(*f* 175); Izaak Hoogenbergh sale,
Amsterdam, 10 April 1743, lot 38 (*f* 150
to Lormier); Willem Lormier sale, The
Hague, 4 July 1763, lot 245 (*f* 460 to
T.P.C. Haag for William V); Prince
William V, The Hague, 1763–1795;
Musée Napoléon, Musée du Louvre,
Paris, 1795–1815; Prince William V
Gallery, 1815–1822; Royal Picture
Gallery Mauritshuis, 1822 (inv. no. 168)

10

'As the Old Sing, So Twitter the Young',
c. 1668/70
Canvas, 134 × 163 cm

PROVENANCE
Hermina Jacoba, Baroness of Leyden
(born Countess Thoms), Warmond,
sale 31 July 1816, lot 35 (*f* 1260 to art
dealer C. Josi for J. Steengracht);
Jonkheer Johan Steengracht van
Oostkapelle and heirs, The Hague,
1816–1913; H.A. Steengracht van
Duivenvoorde, Paris, sale 9 June 1913,
lot 70 (*f* 375,000); Royal Picture Gallery
Mauritshuis (acquired with the support
of the Rembrandt Society), 1913 (inv.
no. 742)

11

As the Old Sing, So Twitter the Young,
*c.*1663/65
Canvas, 84 × 92.6 cm
Lower right on the brass mortar:
.STEEN.

PROVENANCE
Prince William V, before 1775–1795;
Musée Napoléon, Musée du Louvre,
Paris, 1795–1815; Prince William V
Gallery, 1815–1822; Royal Picture
Gallery Mauritshuis, 1822, Prince
William V Gallery, 2010 (inv. no. 169)

12

*The Life of Man, c.*1665
Canvas, 68.2 × 82 cm
Signed on a column at the right:
JSteen (JS interlaced)

PROVENANCE
Adriaan Bout sale, The Hague,
11 August 1733, lot 134; Benjamin da
Costa sale, The Hague, 13 August 1764,
lot 62 (*f* 1745 to Haag for William V);
Prince William V, The Hague, 1764–
1795; Musée Napoléon, Musée du
Louvre, Paris, 1795–1815; William V
Gallery, 1815–1822; Royal Picture
Gallery Mauritshuis, 1822 (inv. no. 170)

13

*'The Caudle Makers', c.*1665/70
Panel, 41 × 31.5 cm
Signed lower right:
JSteen (JS interlaced)

PROVENANCE
Jan Jacob Brants sale, Amsterdam,
20 April 1813, lot 28 (*f* 400 to J. de Vos);
Baron van Verschuer, The Hague,
B.A. Baron van Verschuer et al. sale,
Amsterdam, 26 November 1901, lot 433
(*f* 6600 to Van Hulck); Miss M.C. van
den Honert, Hilversum (on loan to the
Mauritshuis since 1954); Royal Picture
Gallery Mauritshuis (gift of M.C. van
den Honert), 1957, Prince William V
Gallery, 2010 (inv. no. 920)

14

*A Pig Belongs in the Sty, c.*1674/78
Canvas, 86 × 72 cm
Signed lower right:
JSteen (JS interlaced)

PROVENANCE
Gerardus Vogel sale, Rotterdam, 3 July
1755, lot 30; possibly Pieter Foucquet
sale, London, 10/11 February 1773,
2nd day, lot 33; Henry Doetsch sale,
London, 22 June 1895, lot 428 (£ 52 to
J. Murray for Bredius); Abraham
Bredius, The Hague, 1895–1946 (on loan
to the Mauritshuis since 1911); Royal
Picture Gallery Mauritshuis (bequest of
Abraham Bredius), 1946 (inv. no. 736)

Bibliography and acknowledgements

For this book the following literature was consulted:

- Amsterdam-Washington 1996–1997
 H.P. Chapman, W.Th. Kloek and A.K.Wheelock, Jr., *Jan Steen — Painter and Storyteller*, Amsterdam (Rijksmuseum), Washington (National Gallery of Art), 1996–1997
- M.J. Bok, 'The Artist's Life', in Amsterdam-Washington 1996–1997, pp. 24–37
- K. Braun, *Alle tot nu bekende schilderijen van Jan Steen*, Rotterdam 1980
- B.P.J. Broos, *De Rembrandt à Vermeer*, The Hague (Mauritshuis), 1986
- Q. Buvelot *et al.*, *Tableaux Flamands et Hollandais du Musée Fabre de Montpellier*, Paris-Montpellier 1998, pp. 196–199, no. 53
- Q. Buvelot, 'A Whimpering Toddler', *Mauritshuis in focus* 22, no. 1 (2009), pp. 27–30
- M. Bijl, 'The Artist's Working Method', in Amsterdam-Washington 1996–1997, pp. 82–91
- H.P. Chapman, 'Jan Steen as Family Man — Self-Portrayal as an Experiential Mode of Painting', *Nederlands Kunsthistorisch Jaarboek* 46 (1995), pp. 368–393
- H.P. Chapman, 'Jan Steen, Player in his Own Paintings', in Amsterdam-Washington 1996–1997, pp. 10–23
- S.A.C. Dudok van Heel, *Van Amsterdamse burgers tot Europese aristocraten*, The Hague 2008, pp. 194–200
- M. Gifford and M. Palmer, 'Jan Steen's Painting Practice — *The Dancing Couple* in the Context of the Artist's Oeuvre', *Conservation Research 1996/1997 — Studies in the History of Art* 57 (1997), pp. 127–155
- F. Grijzenhout and N.C.F. van Sas, *The Burgher of Delft — A Painting by Jan Steen*, Amsterdam 2007
- E. de Jongh, 'Jan Steen, So Near and Yet So Far', in Amsterdam-Washington 1996–1997, pp. 38–51
- W.Th. Kloek, *Een huishouden van Jan Steen*, Hilversum 1998
- W.Th. Kloek, *Jan Steen (1626–1679)*, Zwolle-Amsterdam 2005
- I. Németh, 'Het spreekwoord "Zo d'ouden zongen, zo pijpen de jongen" in schilderijen van Jacob Jordaens en Jan Steen: motieven en associaties', *Jaarboek Koninklijk Museum van Schone Kunsten Antwerpen* 1990, pp. 271–286
- E. Petterson, *Amans Amanti Medicus: Das Genremotiv Der ärtzliche Besuch in seinem kulturhistorischen Kontext*, Berlin 2000
- J. Shoaf Turner, 'Another Secure Preparatory Drawing by Jan Steen', *Master Drawings* 47 (2009), pp. 432–436
- P.C. Sutton, M.G. Butler, 'Jan Steen — Comedy and Admonition', *Bulletin Philadelphia Museum of Art* 78 (1982–1983), pp. 1–64
- L. van der Vinde, 'The Girl in the Poultry Yard', *Mauritshuis in focus* 22, no. 3 (2009), pp. 8–14
- L. de Vries, *Jan Steen "de kluchtschilder"*, Groningen 1977
- L. de Vries, 'Steen's Artistic Evolution in the Context of Dutch Painting', in Amsterdam-Washington 1996–1997, pp. 68–80
- M. Westermann, 'Steen's Comic Fictions', in Amsterdam-Washington 1996–1997, pp. 52–67
- M. Westermann, *The Amusements of Jan Steen. Comic Painting in the Seventeenth Century*, Zwolle 1997

We are particularly indebted to the *Johan Maurits Compagnie*, who made it possible to restore 'As the Old Sing, So Twitter the Young', *The Doctor's Visit* and *A Pig Belongs in the Sty*. The restoration of *Woman Playing a Cittern* was made possible by the generous support of Johnny Van Haeften, London.

With thanks to Sabrina Meloni, Carol Pottasch and Annelies van Loon, who carried out the restoration and technical examination of '*As the Old Sing, So Twitter the Young*' (S. Meloni and C. Pottasch), *A Pig Belongs in the Sty* (S. Meloni), *Woman Playing a Cittern* (S. Meloni), *The Doctor's Visit* (S. Meloni) and *Peasants Dancing at an Inn* (A. van Loon and S. Meloni).

Text
Ariane van Suchtelen, Mauritshuis

Translation
Diane Webb

Design
DeLeeuwOntwerper(s), The Hague

Procurement of photos
Geerte Broersma, Mauritshuis

Publishing
Waanders Publishers, Zwolle
Royal Picture Gallery Mauritshuis, The Hague

Printing
ÈposPress BV

© 2011
Uitgeverij Waanders B.V.
Royal Picture Gallery Mauritshuis

ISBN 978 90 400 7763 0
NUR 643

www.waanders.nl
www.mauritshuis.nl